DIY

TEMPORARY

Tattoo

Art

EASY STEP-BY-STEP INSTRUCTIONS FOR

Watercolor, Henna, Flash Tattoos, and More!

K.L. CAO

ADAMS MEDIA

New York London Toronto Sydney New Delhi

Adams Media
An Imprint of Simon & Schuster, Inc.
57 Littlefield Street
Avon, Massachusetts 02322

First Adams Media trade paperback edition JULY 2017

ADAMS MEDIA and colophon are trademarks of Simon and Schuster.

For information about special discounts for bulk purchases, please contact Simon & Schuster Special Sales at 1-866-506-1949 or business@simonandschuster.com.

The Simon & Schuster Speakers Bureau can bring authors to your live event. For more information or to book an event contact the Simon & Schuster Speakers Bureau at 1-866-248-3049 or visit our website at www.simonspeakers.com.

Interior design by Sylvia McArdle
Interior images © K.L. Cao and Gerald Washington

Manufactured in the United States of America

10 9 8 7 6 5 4 3 2 1

Library of Congress Cataloging-in-Publication Data has been applied for.

ISBN 978-1-5072-0237-1
ISBN 978-1-5072-0238-8 (ebook)

Dedication

For as long as I can remember, I've always wanted to dedicate something to my mom. I couldn't figure out if the place to do it was while being interviewed for an online article, or if waving to her while I photobombed other people's vacation photos was enough. I just knew deep down in my heart that if I ever got a real chance to dedicate something to my mom—otherwise known as Momzies via my social media posts—I'd do so.

 This book is for my mom. To this lovely lady who overcame so many obstacles pitted against her. For all the things she's done for me and will continue to do for me out of the pureness of her love. She's always taught me to work hard and do the best that my capabilities allow, but at the same time—at the end of it all—she's always only wanted me to be happy. To be totally honest, if I don't write out her full name, she won't believe that I've dedicated this book to her. Here we go: *Lieu Nguyen*, this book is dedicated to you! Of course, she'd be really upset if I didn't mention both my puppy brother, Plato, and my Ba (dad), Thoan Cao—so I am sneaking that in right now.

Love,
K.L Cao

Contents

Introduction 7

CHAPTER 1

Get Started 9

Prep Your Skin 10
Tools and Techniques 11

CHAPTER 2

Flower Power 15

Floral Watercolor Pastels 17
Pressed Flowers 21
Floral Henna 27
Metallic Lotus Flowers 31
Floral Tissue Paper 37
Wallflowers 41

CHAPTER 3

Electric Style 47

Glowing Armbands 49
Glow-in-the-Dark Blush 53
Nighttime Jewels 55
Masquerade 61
After-Dark Henna 65

CHAPTER 4

Make a Statement . . . 69

Statement Glitter 71
Visible Garter 75
Large Henna Chest Piece 79
Metallic Henna Jewelry 83

CHAPTER 5

Wild Kingdom 87

White Henna Zebra................89
Rainbow Sparrows91
Metallic Unicorn Horn95
Low-Poly Tissue Paper Fox99
Delicate Feathers103
Glitter Unicorn107

CHAPTER 6

Shine Bright 111

White Sparkling Stars113
Glowing Constellations115
Golden/Silver Stars...............119
Sparkling Aurora 123
Intergalactic 127
Our Universe131

CHAPTER 7

Beautify Me135

Gold Headbands137
Floral Hair.......................141
Sunset Coachella..................145
Golden Freckles..................149
Henna Nail Art...................151
Tattoo Stains....................155
Painted Cuticles.................159

Appendix A: Tattoo Templates162
Appendix B: U.S./Metric
Conversion Chart 176

Acknowledgments

If I could, I would list every single one of my followers on *Facebook*, *Twitter*, *Instagram*, and *YouTube*. If it weren't for these fine virtual folks, I wouldn't have gotten this fantastic opportunity to share more of my work with the world. To you guys of Sloabie Nation, y'all surely rock!

I cannot start this book without mentioning my fantastic manager, Sir Chas Lacail-lade. He's always the one who reminds me that I have a handle on something, and if I needed extra time or resources, he'd help me out. I'd also like to give thanks to my photographer, Just Gerald (Gerald Washington), who's worked for me on just a staple of Chex Mix and fruit.

I'd like to thank a special companion, someone who's always reminded me to laugh and take a breath when I am totally stressed out. All the J-Kays are what got me through long nights of crafting. Lastly, I'd like to thank the awesome team members over at Adams Media for helping me put this book together. I had no idea how to write or even start a book, and you guys made it possible!

Introduction

Have you ever wanted to rock a gorgeous chest tattoo? Mark your skin with armbands that cause everyone to take notice—even when the lights are off? Make a statement with a sensual garter that doesn't come off at the end of the night?

Have you been too nervous to take the plunge and make these marks permanent? Well, if that sounds familiar, you're in the right place! Here you'll find more than thirty temporary tattoos created with a number of on-trend techniques and materials that you can try on for size. If you want to go out bedecked in glitter or metallics, try the Statement Glitter tattoo or the Gold Headbands tattoo. If you want to light up the night, paint yourself in glow-in-the-dark or UV-activated paints with the Nighttime Jewels, Masquerade mask, or Glow-in-the-Dark Blush tattoo. And if you want to show off your inner hippie chick at your favorite music festival, try the Floral Watercolor Pastels or Wallflowers tattoo.

If you think you'll just be sticking on some tattoo paper, you better think again. While you'll find projects that keep it simple, you'll also find materials that are as varied and outside of the box as the looks themselves. You'll find tattoos created with henna ink, tissue paper, powdered drink mix, stickers, body paint, eyelash glue, and even gold!

And the best part of these temporary tats? Once you figure out what you love and how to get it, you can use your creativity to personalize your skin . . . and isn't that just what tattoos are meant to do anyway?

Get Started

Now, you're obviously excited to jump right in and try all the temporary tattoos in the book. But you need to hold yourself back for just a little bit, because before we get into any of that, you need to learn some simple preparatory techniques and you need to make sure you have the tools on hand to create these awesome designs. Let's take a look at what you need . . .

Prep Your Skin

Your work is only as great as the canvas you work on, and given that your skin will be your canvas, you need to make sure it's ready for the temporary tattoos. Here you'll find some info on how to prep your canvas and make sure your tattoo—not an allergic reaction or greasy skin—is the star of the show.

TEST THE PRODUCTS

Nothing ruins a good time like hives, swelling, and itchiness that could last for days, so it's important that you make sure you're not allergic to any of the products you'll be using. Before using any of these items, test out the product in a small and inconspicuous place to see if you react negatively to it. Now, keep in mind that not every tattoo project uses the same materials or products. So if your skin doesn't like something, you can always try out another project or find a product substitution that works for you. Don't worry, there are so many techniques and awesome designs here that you're sure to find one that works for you.

CLEAN YOUR SKIN

If you're taking the time and effort to apply a totally awesome temporary tattoo, you want to make sure it's going to last. So before you begin to apply the tattoo, take the time to cleanse your skin with simple soap and water. The cleaner your skin, the better these designs will adhere to it. And, if you

really want to take it up a notch, exfoliate your skin with a simple exfoliating scrub. Don't forget that your skin goes through a monthly cell cycle. If you want your design to last longer, it's best to have it adhere to skin that isn't ready to slough off anytime soon.

Once your skin is clean, take the time to let it dry thoroughly before starting the application process. Letting your skin dry for about 10 minutes will allow for the best adherence of your tattoo. The sticky part of the tattoo sheets will have a greater chance of gripping onto your skin rather than the water molecules.

KEEP YOUR SKIN CLEAR

Imagine placing a sticker onto carpet or onto a gravel road. Chances are good that it's not going to stick. The same concept applies when you try to adhere temporary tattoos to skin that has a lot of hair on it, or skin that isn't quite smooth. So when you're figuring out where to place your tattoos, try to find a place on your body with a smooth surface. If you really want to go the extra mile to make sure your design is sticking to your body, you can also shave the area where you want to apply your temporary tattoos as well. Keep in mind that some projects will work on stubbly hairs and others won't. It's best to have completely smooth skin, or your tattoos might not last as long as you'd like them to.

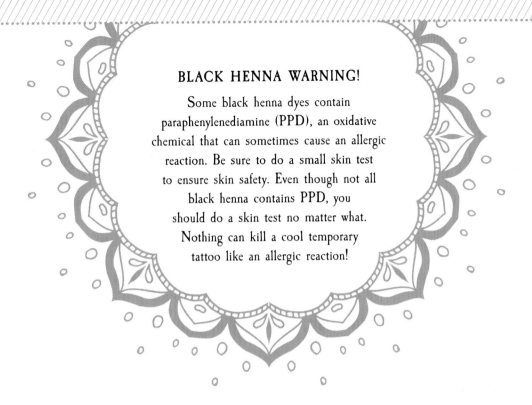

BLACK HENNA WARNING!

Some black henna dyes contain paraphenylenediamine (PPD), an oxidative chemical that can sometimes cause an allergic reaction. Be sure to do a small skin test to ensure skin safety. Even though not all black henna contains PPD, you should do a skin test no matter what. Nothing can kill a cool temporary tattoo like an allergic reaction!

In addition, you should avoid covering up any cuts, scrapes, or blemishes with temporary tattoos. It might just make the cut worse and those things definitely need some oxygen in order to heal.

Tools and Techniques

There are a ton of designs throughout this book that you can absolutely throw your creativity into, but regardless of how unique each one of the designs is, they do have a common set of tools and even techniques that will surely give you a more polished look. But don't worry, you'll be surprised to see how many of these things you already have at home, and even the items that you have to buy online don't cost a lot. Remember, an artist is only as great as her toolbox, so make sure you have everything you need before you get started.

PRINTER/COPIER

A printer is important for these projects especially if you feel that you don't have any artistic skills. You can find inspiration all over the Internet and

then print out those images and incorporate them into your tattoo. Or you can scan the templates found in Appendix A at the back of the book and print them out to use, which is what the projects call for you to do. This way, you won't feel like you are hindered from great temporary tattoo designs just because you can't draw a straight line. (Trust me, without a ruler—I can't either.)

TEMPORARY TATTOO PAPER

To go along with the printer, you'll need to have temporary tattoo paper on hand. There are many different brands of temporary tattoo papers on the market (I use a combination of Silhouette Temporary Tattoo Paper and Tattify Temporary Tattoo Inkjet Paper, available in craft stores and online at Amazon.com), but you'll want to buy the paper that works in the printer that you have available.

Most temporary tattoo paper kits come with two different sheets of paper:

- The first sheet is the **printable tattoo sheet**, which is what you'll print your design on.

- The second sheet is a **double-sided adhesive sheet** that sticks to both the temporary tattoo sheet and to your skin.

When using the tattoo paper, be sure to follow the instructions on the kit closely. That said, most suggest that you remove the paper backing from the double-sided adhesive sheet and press it firmly against the printed image. Then you'll use a straightedge or a credit card to smooth out any lumps or bubbles. Use scissors to cut around the image and then set it aside until you are ready to wear it on your skin.

CUTTING TOOLS

Some of the designs that you'll find throughout the book can be quite precise, while others, not so much. Either way, in order to cut and snip out details of your designs you will need a pair of sharp paper-cutting scissors or any mixed-media scissors that can handle different materials. Also, for some of these projects it's best to have a craft knife to slice out the foreground image from the background. To go along with this, a self-healing cutting mat will make working with your craft knife a lot easier and safer. You can find each of these tools in craft stores or online at a minimal cost.

APPLICATION TOOLS

The temporary tattoos in this book are so easy to apply. If you are working with temporary tattoo paper, you can easily apply each tattoo using a bit of water and a makeup wedge. The best way to do this is to squeeze the makeup wedge before submerging it in a small cup or bowl of water. Allow the sponge to soak up the water which will only take 2–3 seconds. Take it out of the water and shake it once or twice to remove excess water from the wedge. Place the wedge against the backing of the tattoo paper and dab. Keep dabbing until you have completely soaked the paper, which will loosen the design from the paper.

Other adornments such as flowers and rhinestones will require a little more than just water. To make sure these stay in place you want to have a lot of eyelash glue on hand. You can find eyelash glue in the beauty aisle of your local drugstore, and because the type of glue you need to have varies depending on the project, it's best to have both brush-on eyelash glue and a squeeze tube of eyelash glue on hand. To use the glue, simply place a dot on your skin and attach whatever you like to it.

Lastly, it's best to have a variety pack of paint or makeup brushes. The ones regularly listed in this book are a ¼" flat brush for glitter application, a fine liner brush for intricate details, and a large makeup blush brush for dusting on products. However, just because I've listed these three brushes, it doesn't mean you have to stick with them. By all means, use whichever brushes are easiest for you. I've just found that these are great brushes to get started with.

REMOVAL TOOLS

The real world can eventually catch up to all of us, so you might not be able to wear your unique art pieces for as long as you might like. Have no fear! While some of the tattoos in this book take a little more elbow grease to remove than others, they are all temporary.

If you are trying to remove tattoo paper, simply take a pair of tweezers and lift up enough of the corner so you can peel off the rest. Anything that is painted on, dusted on, or has lash adhesive added to it can be gently wiped off with a makeup remover wipe and some coconut oil.

Henna tattoos will take a little extra work to remove. These tattoos can last up to 3 weeks, so instant removal can be quite tricky. If for whatever reason you need to remove your henna tattoo immediately, no problem. Just soak a cotton ball in hydrogen peroxide and rub it over your skin for a few minutes or until the tattoo disappears. An equal mixture of dish soap, lemon juice, and baking soda applied with a washcloth will also do the trick if you don't have hydrogen peroxide on hand. Keep in mind that removal ingredients can be harsh on the skin, so be sure to do a quick skin test before trying out the removal process. If you aren't in a huge hurry to remove your henna tattoo, you can use a fine exfoliating scrub. With regular usage you should be able to remove it within a week or so. If you don't have a scrub on hand, coconut oil mixed with sugar makes a great natural exfoliator as well.

So now that you know how to prep your skin to apply the temporary tattoos, and you know what you should have on hand to put them on and take them off safely, it's time to embrace your inner rebel and express your vibrant self by putting on some ink!

Flower Power

Throughout history, flowers have been used to decorate homes, show love, and even infuse beauty and symbolism into weddings and more. Want to pay some major respects and kudos to these petals? Wear pressed flowers on your skin as you dance the night away at Lollapalooza. Decorate your body with henna for the first time. Or add a golden hue to a flower you've seen many times and showcase it on your back. However you decide to wear them, floral tattoos aren't going to disappear anytime soon, so gather up your flower power and give them a go!

Floral Watercolor Pastels

Remember when a box of crayons set your imagination free? With this project you can let pastels do the same! Pastels are easy to find, and with just a few beautiful colors, an innovative design, and some rhinestones you can create a floral landscape right on your skin.

MATERIALS

➤———————➤

* Face and body paint crayons
 (I used white, red, light blue, dark blue, green, and yellow by Shuttle Art)

* 1 (0.18-ounce) tube brush-on eyelash glue

* 10–15 (5 mm) clear rhinestones

* Tweezers (not pictured)

* * *

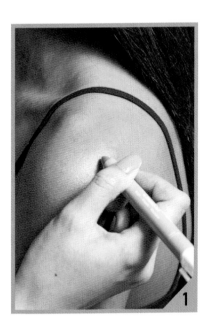

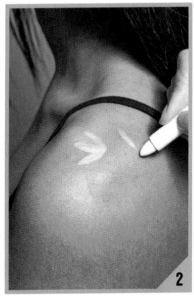

1. Take the light blue crayon and draw some simple petals on a small patch of skin to see how opaque the colors are against the skin complexion. Testing out each color will help you figure out how best to layer your colors so the finished flowers really pop.

2. Choose a spot on the body to start your design and use the white pastel to draw simple dots, vines, and petals to create a base for the rest of the design. I chose to start the design at the top of the shoulder. In this project the

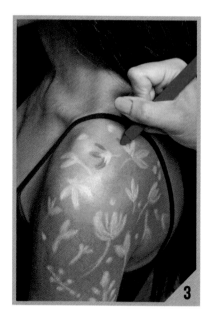
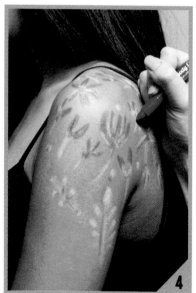
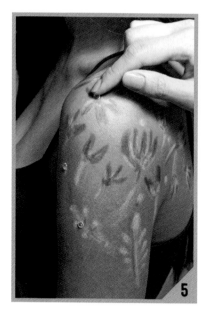

flowers are pretty easy. Simply draw 3–5 petals coming from a center point. Then, draw a long wispy stem that attaches to it. To create the leaves draw a straight line and add dots on both sides of the stem.

3. Take the red crayon and use it to color in the tips of the petals of the white flowers.

4. Use the dark blue crayon to color right below the red part of the petals, then take the orange crayon and dab a little bit of orange at the center of each flower. Next, take the green crayon and color over the white base of the stems.

5. Next, use the brush of the eyelash glue to place a dot of glue on the skin either between or on top of the flowers. Pick up a rhinestone with the tweezers and place it on top of the glue. Press gently until the rhinestone adheres. Repeat with the remaining rhinestones until you're happy with the design.

6. Allow the glue to set about 10 minutes, then dance the night away with this Floral Watercolor Pastels tattoo! ▸

TATTOO TIPS

As you color in the flowers, let
your eyes tell you what looks best.
If the tattoo is drawing more
attention in one area, go ahead and add
more colors to the area that doesn't
get enough attention to balance out the
look. You want to love your look, so
make sure you're happy with whatever
you decide to put on your skin.

Pressed Flowers

Have you ever pressed flowers? Or maybe you forgot to add water to an arrangement? Either way, this Pressed Flowers tattoo gives these dried-out blooms a second chance and turns them into a beautiful wearable garden. So if you want to enjoy that loving bouquet that was sent to you for a just a bit longer—and be a little bohemian chic at the same time—this temporary tattoo is just perfect.

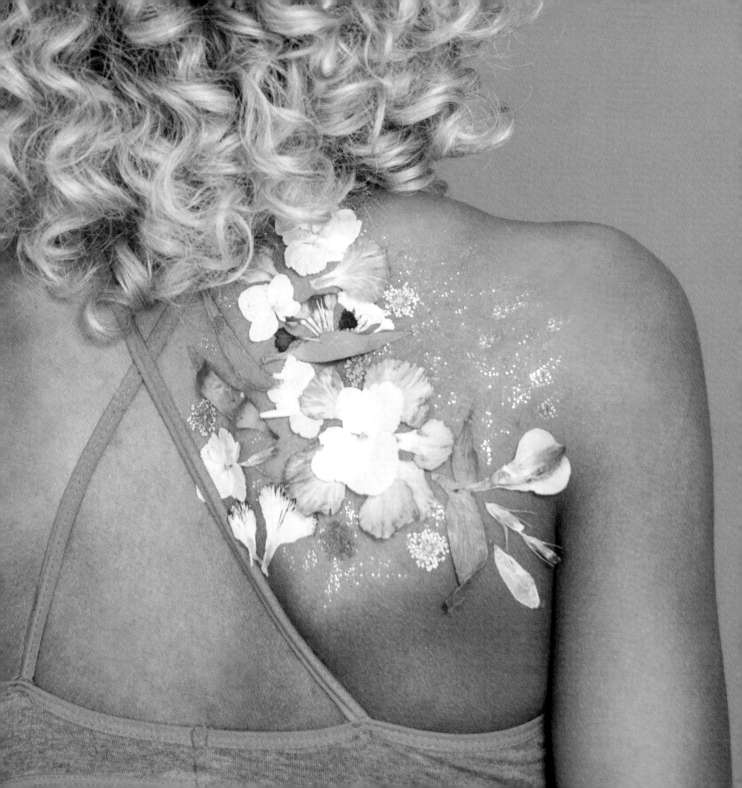

MATERIALS

* Assorted flowers (I used 1 carnation, 1 hydrangea, and 1 sweet William)

* 2 (4" × 5" × ¼") wooden blocks
(Note: The size of the blocks is optional, as long as both are the same size.)

* 2 (12" × 7") paper towels

* 3 rubber bands

* Tweezers (not pictured)

* 1 (0.18-ounce) tube brush-on eyelash glue

* 6 pressed, dried mini baby's breath
(Note: They come in different colors; and I used 2 purple, 2 white, 1 pink, and 1 blue for this look.)

* 1 (¼") angled brush

* Silver cream eye shadow glitter

★ ★ ★

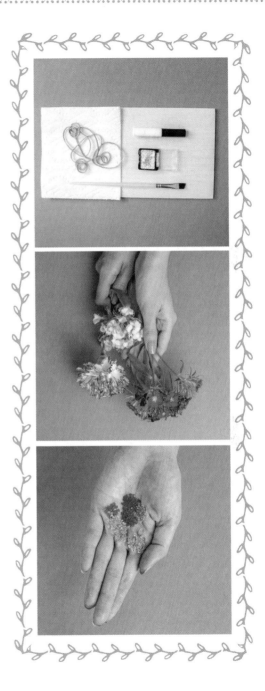

1. Carefully remove the petals and leaves from the flowers. Select 5–10 petals from each flower that are large and can lay flat on their own. Then select 8–10 leaves from each flower that can lay flat.

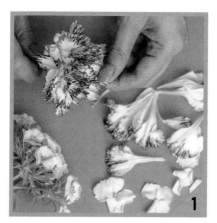

2. Place a wooden block on a work surface and lay a paper towel on top of it.

3. Place the petals and leaves on the paper towel without over-lapping. Then carefully cover the petals with the remaining paper towel and place the second wooden block on top.

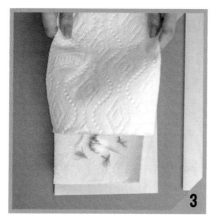

4. Bind the blocks together tightly by placing a rubber band around each end of the short sides of the blocks and another around the long side of the blocks.

5. Place the blocks in the microwave and heat for 30 seconds. It's best to check halfway through to make sure you are not burning the petals.

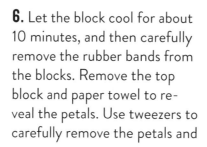

6. Let the block cool for about 10 minutes, and then carefully remove the rubber bands from the blocks. Remove the top block and paper towel to reveal the petals. Use tweezers to carefully remove the petals and

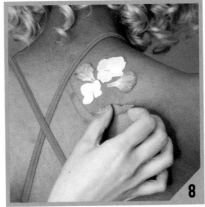

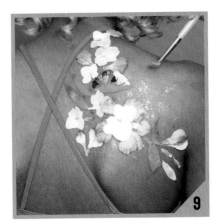

leaves from the paper towels and set aside for 5–10 minutes to cool to room temperature. (You can also make extra and store them in an airtight container for other craft projects or tattoos.)

7. To apply the flowers, pick an area that is pretty flat such as the shoulder blade. Use the eyelash glue brush to add a dot of glue to the skin.

8. Place the petals and leaves on the glue, starting with the larger petals. The best way to get a dynamic look is to overlap the flowers. Try placing some hydrangeas on top of the carnation petals or leaves slightly on top of the sweet William. Add a few of the colored, pressed baby's breath around the edges of the tattoo to make the look more dynamic. As you arrange the leaves and petals be sure to use a mix of different types of flowers and sizes to create an elaborate design. After you have arranged all the flowers and leaves, allow the glue to dry for about 10 minutes.

9. Use the angled brush to add cream glitter around the flowers. Allow the cream glitter to set about 5 minutes. Now you're ready to show off this new tattoo! ▸

TATTOO TIPS

Feel free to use any flowers that are light and bright in color for this project. Flowers with contrasting colors such as carnations look more dynamic when dried. Also, to press a whole flower, try selecting smaller blooms of baby's breath, dianthus, or hydrangeas. In addition, when you're heating the flowers in the microwave, be sure to increase the heating time for petals that are thicker, such as those of roses or tulips, and lower the heating time if the petals are thin, such as hydrangea petals.

Floral Henna

If you've ever seen henna tattoos—temporary adornments drawn on the body with ink made from the henna plant—you probably remember the iconic flowers and vines that set the art form apart. The flowers seen in these tattoos represent happiness and joy and the creeping vines represent longevity and prosperity in a relationship, which is why they are traditionally seen on brides in regions of India and elsewhere. Apply these Floral Henna tattoos before heading out to a festival and leave no doubt as to your own joy and happiness!

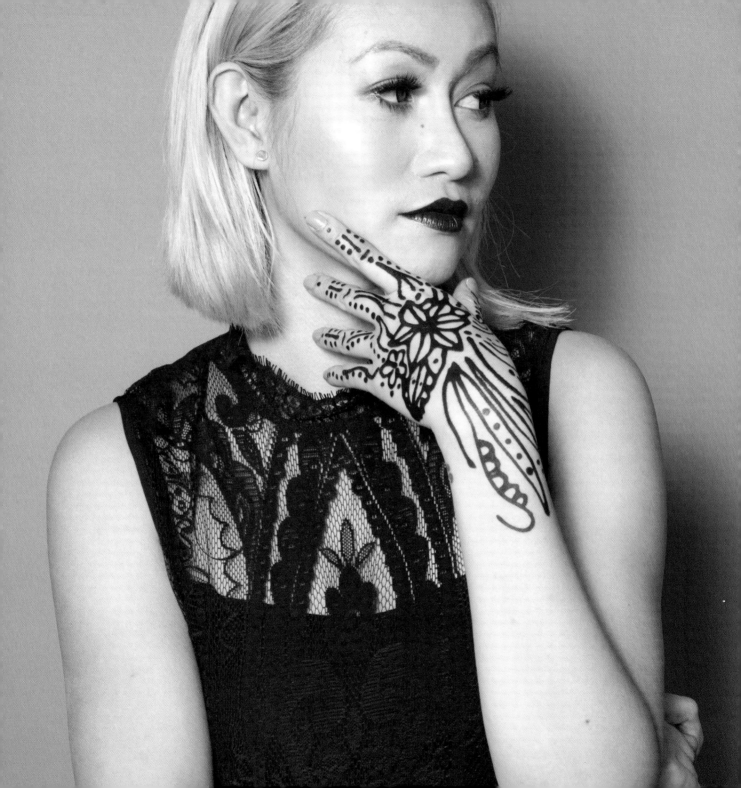

MATERIALS

➵➝

* Scissors *(not pictured)*
* 1 (1-ounce) tube black henna ink
* 1 (1-ounce) applicator bottle with needle-tip cap (0.7–1 mm)

* * *

1. Use the scissors to cut off the tip of the henna tube and squeeze the ink into the applicator bottle.

2. Test out the henna by squeezing a small dot onto a piece of scrap paper. Squeeze out 3–5 lines that are 3" long and ⅛" thick until you feel that you can confidently control the henna application process. ▸

3. Squeeze the bottle to release the ink and draw a large daisy in the center of the back of the hand, or wherever you decide to place the tattoo.

4. Accent the flower with dots, squiggles, lines, and leaves—or whatever looks good to you.

5. Once you're happy with the flower and accents, allow the henna to dry for 1 hour or until you see some of the henna flaking off on its own. It should be dry to the touch. Then enjoy your artwork for up to 3 weeks! If the henna does not flake off with gentle brushing, it usually means it hasn't dried all the way through. Give it another 10 minutes of drying time.

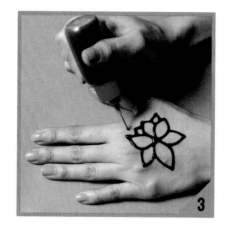

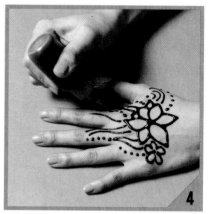

TATTOO TIPS

When you accent the henna flower in step 4, keep in mind that henna does expand while drying. To avoid a large blob, use a smaller applicator tip, or keep the designs more simplistic. Also, if you're not happy with how your design is coming out, simply dip a cotton swab into some coconut oil or olive oil and apply it to the ink to remove the henna. It's best to do this the moment you realize you've made a mistake!

Metallic Lotus Flowers

The lotus blossom traditionally represents beauty and rebirth. And just like the lotus flower, you can rise out of the dark mucky water of a difficult time and blossom into something new and beautiful. This Metallic Lotus Flowers tattoo acts as a beautiful (and completely badass) badge of honor that lets you broadcast your strength to the world.

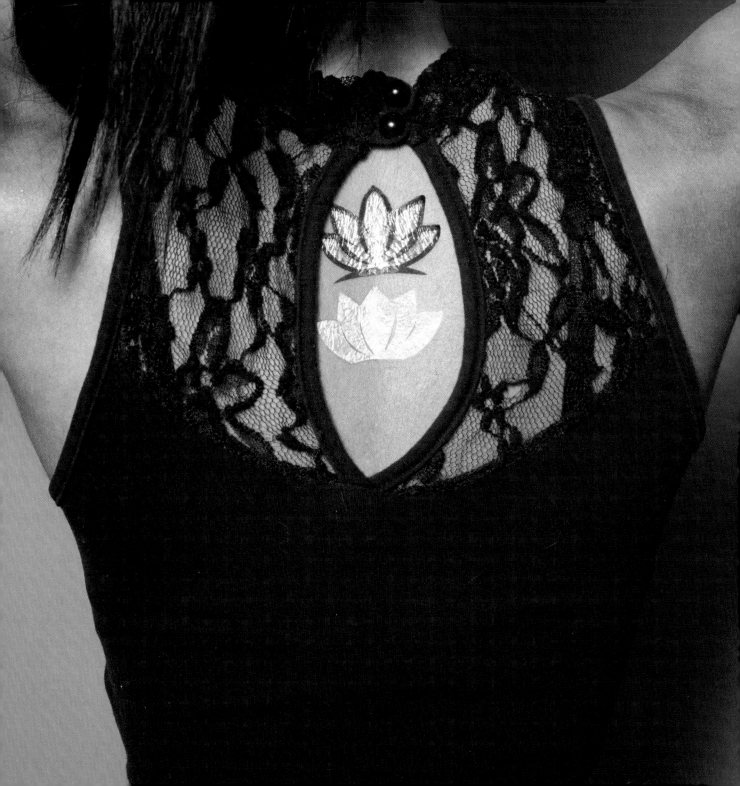

MATERIALS

* Metallic Lotus Flowers template (Appendix A) *(Note: This template has two images: "Lotus Image 1" without the circle and "Lotus Image 2" with the circle.)*

* 1 temporary tattoo paper kit with a clear adhesive paper sheet *(not pictured)*

* 1 (2.7-ounce) nontoxic all-purpose glue stick

* 1 (3.15" × 3.15") sheet gold leaf

* 1 (¼") flat brush

* 1 (⅜") flat brush

* Scissors

* Craft knife

* 1–2 makeup wedges

* * *

1. Scan the Lotus Image 1 template into your printer and print on the shiny side of the tattoo paper.

2. Scan and print a mirror image of Lotus Image 1 on the opposite side of the same piece of tattoo paper.

3. Lay the tattoo paper on a work surface with the shiny side facing up and coat the entire image with glue. ▸

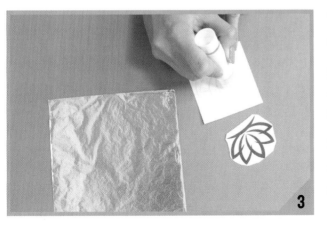

3

4. Tear out 4–5 (½–1") pieces of gold leaf and apply them to the glue. Use the larger flat brush to gently brush out any air bubbles and wrinkles. If your gold pieces are small, you can use a small flat brush to pick up the gold pieces and brush them onto the glue.

5. Repeat steps 1–4 with Lotus Image 2.

6. Take the adhesive sheet that came with the tattoo kit and cut out a piece that will cover Lotus Image 1. Remove the paper backing from the adhesive sheet.

7. Lay the adhesive sheet flat, with the tacky side facing you. Press the lotus image onto the adhesive with the gold side facing down.

8. Use scissors to cut out the image.

9. Repeat steps 6–8 with Lotus Image 2, but cut around the circle surrounding the lotus.

10. Use a craft knife to cut out the lotus inside of the circle. You're creating a stencil, so take care not to cut the circle itself. Cut out small slits in the lotus where it looks like there is a separation in the petals.

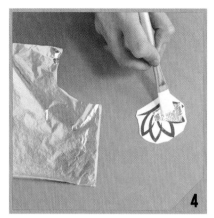
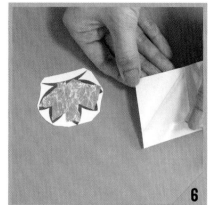
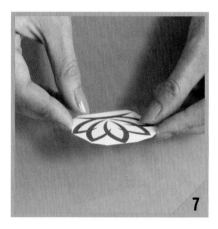
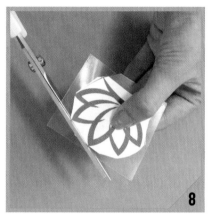
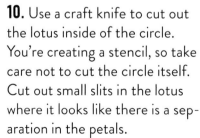
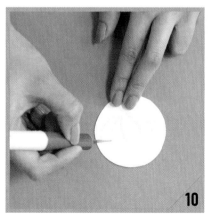

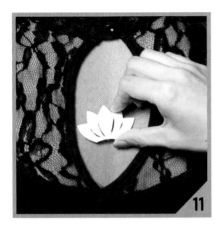

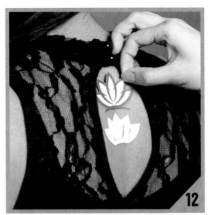

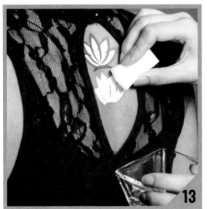

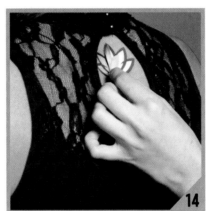

11. Remove the clear film that is attached to the tattoos, and place Lotus Image 2 on the upper part of the back right on the spine.

12. Next, place Lotus Image 1 above the one you just placed.

13. Soak a makeup wedge in water and shake off excess. Gently dab the backing of the tattoos with the wedge until the paper is saturated. As you dab the backing will start to slide off the images.

14. Gently peel the backing away from both tattoos and check out the totally rad, peaceful golden flowers you created!

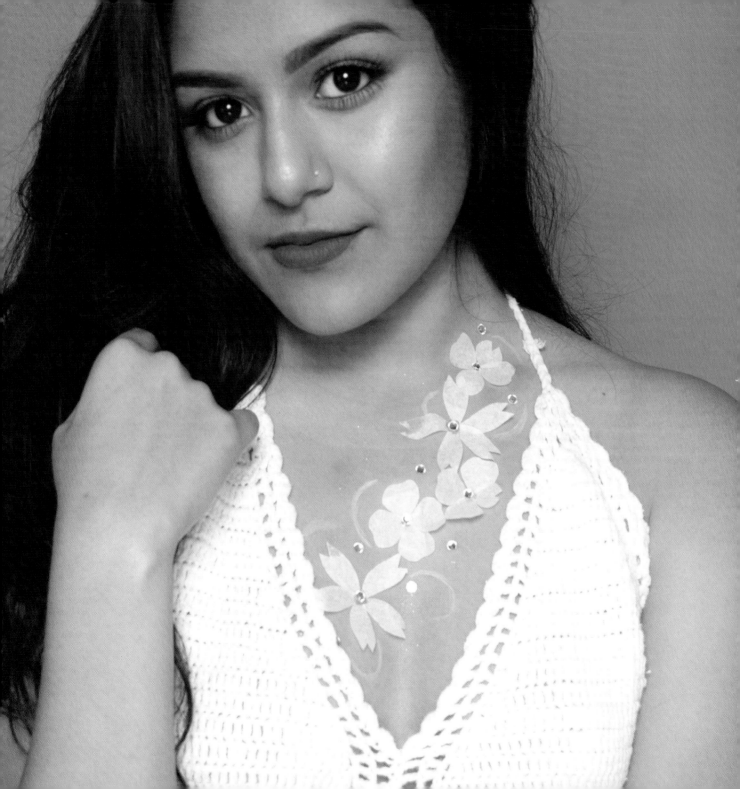

Floral Tissue Paper

If you're in love with the paper flowers used in Cinco de Mayo celebrations, you're going to be so excited about this Floral Tissue Paper tattoo. It's super simple to layer a few pieces of paper together to create a perfect bloom. All you have to do is pull a petal from an actual flower and take notice of its shape, as well as the construction of the flower itself. Then you just cut out the petal shapes from tissue paper and apply them to the skin. With this free-spirited tattoo, you're sure to be inspired to do more than just stop to smell the roses (or the daisies and cherry blossoms!); you'll take the time to really look at them.

MATERIALS

* 2 sheets white tissue paper

* Scissors

* 1 (0.18-ounce) tube brush-on eyelash glue

* 10–20 (5 mm) clear rhinestones

* Tweezers *(not pictured)*

* 1 white liquid eyeliner pen

* * *

1. Take 1 piece of tissue paper and hold it horizontally. Starting at the bottom, fold the paper accordion style 9–15 times. (This should look as though you are trying to fold a paper fan.)

2. Rotate the paper 90 degrees and fold accordion style again 8–12 times. This time you should end up with a square.

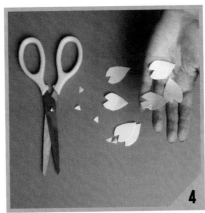

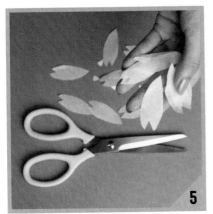

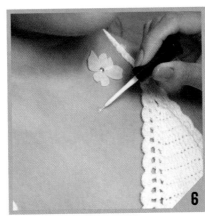

3. Cut out a 2" × 1" teardrop-shaped piece from the paper, starting from the unfolded edge of the tissue paper and cutting through all the layers.

4. At the rounded edge, snip out a small triangle and separate the petals from one another by rubbing the layers between your thumb and forefinger. This will create the cherry blossom petals. It should yield around 30–40 petals, but you will only need 12 of them.

5. Repeat steps 1–4 with the other piece of tissue paper, but instead of cutting out a small teardrop, cut out a long oval, and snip out the small triangle from either edge. This will create the daisy petals. You will need about 10–15 of these petals.

6. Use the brush of the eyelash glue to place a dot of glue at the top center of the collarbone (or wherever you choose to place the tattoo). Apply the pointed tips of 4–5 cherry blossom petals to the glue to create a cherry blossom flower. ▸

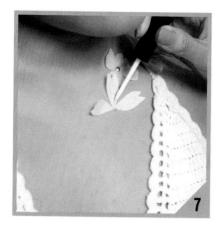 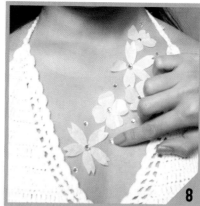 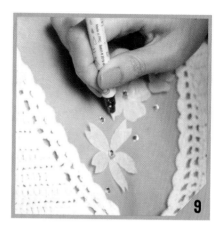

Add a dot of glue to the center of the bloom. Pick up a rhinestone with the tweezers and place it on top of the glue. Press gently until the rhinestone adheres.

7. Under the flower you just created, repeat using the daisy petals. Basically, work from the top of the collarbone near the outside of the neck down toward the sternum using both cherry blossom petals and daisy petals. This will create a nice flow to the flowers.

8. Take the remaining rhinestones and use the eyelash glue to place them around the flowers.

9. Use the eyeliner to create decorative leaves and vines stemming from the petals.

10. Wait about 10–15 minutes for the eyeliner and glue to dry and then head out to rock this look!

Wallflowers

Have you ever looked at wallpaper and even though the patterns are the same, you could still make out another, almost 3D image from it? This is due to the wonderful magic of stereopsis. It's our brain somehow making something stand out from similar patterns. The moral of this is, even if someone seems like a wallflower, you might be surprised by what you see if you take a closer look. However, you won't be a wallflower with this eye-catching design on your body. Instead, get ready to stand out wherever you are, be it the beach, a music festival, or an art show!

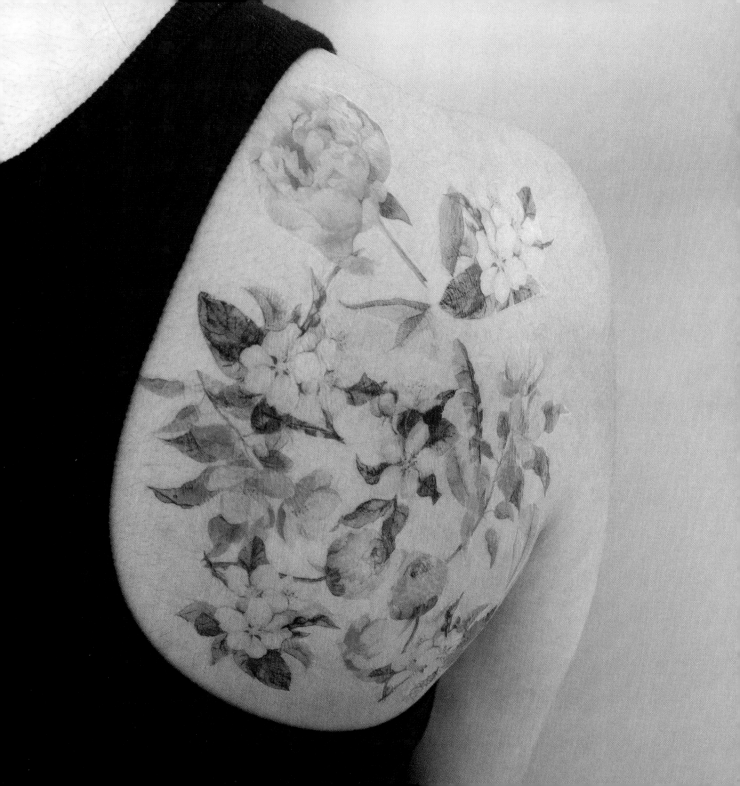

MATERIALS

→

* Scissors
* Wallflowers template (Appendix A) copied on 8.5" × 11" temporary tattoo paper
* 1–2 makeup wedges

* * *

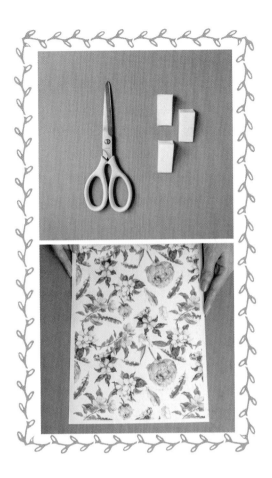

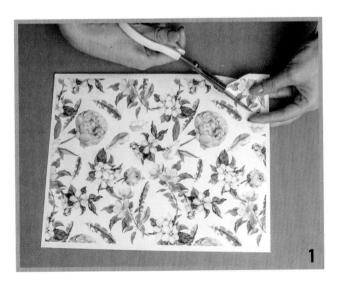

1. Use scissors to carefully cut out each flower, working as precisely as you can. ▸

2. Take one of the cut-out flowers and remove the clear film from the tattoo paper. Place the paper sticky side down on any flat surface of the body where you will have enough room to place all the flowers in your design. (I chose the top back of the shoulder as my starting point.) Press gently to make sure the tattoo adheres to the skin. Repeat with a few remaining flowers to create your first layer of flowers.

3. Soak a makeup wedge in water and shake off excess. Gently dab the backing of the tattoos with the wedge until the paper is saturated.

4. Gently peel the backing away from the tattoos to reveal the images.

5. Repeat application as many times as needed in order to fill in any gaps. In between each application make sure the skin is dry before adding on another layer of tattoos. Once all the tattoos are dry, head out the door and get ready to stand out.

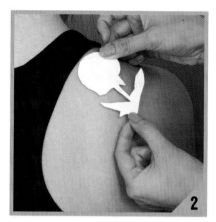
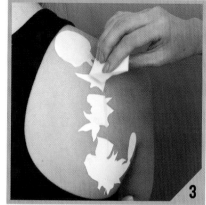
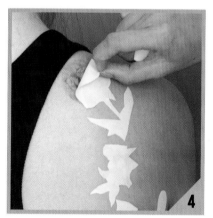
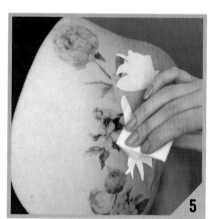

TATTOO TIPS

When you're looking for the flower images online to print on your tattoo paper—if you decide not to use the included template—try searching for vintage floral and vine images. Then, follow the instructions that came with your tattoo paper. Most tattoo paper will ask you to print the image on the shiny side of the white paper and then apply the adhesive layer on the image.

Electric Style

When you think about electricity, it's more than just the thing that charges your phone. It's a spark in the air. A feeling that your night is going to be out-of-this-world amazing. And what better way to show your electricity than DIY tattoos that glow in the dark?

There is nothing more exciting and relevant in today's fashion than seeing your style glow. Here you'll learn how to charge up your inner fashionista by using UV-activated paint to create armbands, make jewelry, and paint on henna. Read on for projects that will make your inner glow something everyone can see.

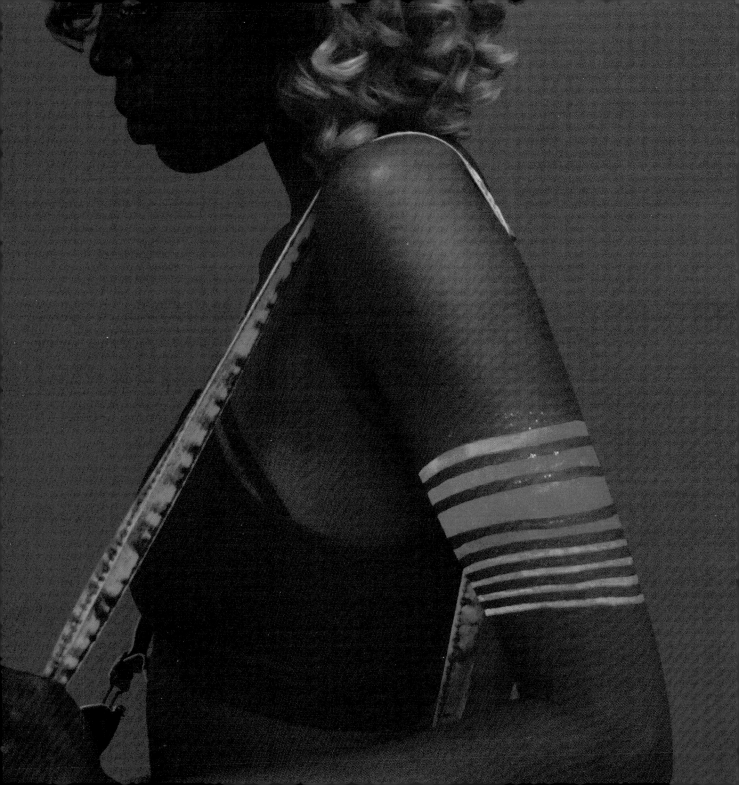

Glowing Armbands

If you're heading out for a wild night but don't want to worry about losing your jewelry, you need to check out these Glowing Armbands. These quick and simple stackable bands are guaranteed to light up the party. If you can use tape and a paintbrush, you can absolutely achieve this look. So turn off the lights and get ready for a night—and a DIY tattoo— as bright and as wild as you are!

MATERIALS

* 1 (4.5 mm) roll washi tape
* Scissors
* 1 (1") flat brush
* 1 (0.5-ounce) tube pink UV-activated paint
* 1 (½") flat brush *(not pictured)*
* 1 (0.5-ounce) tube gel-based silver glitter *(not pictured)*
* UV lamp or bulb *(not pictured)*

* * *

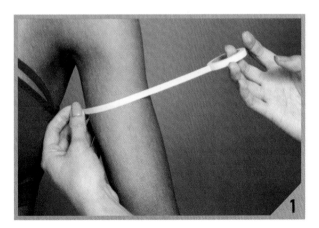

1. Use strips of washi tape to block out 5–7" of the bicep to create the stripes. Add about 9–10 rows of tape, leaving a ¼–½" space between each row. You can make the spacing the same for all rows or vary it as I did to make some bands thicker than others—just do whatever looks best to you. Use scissors to cut the washi tape so the edges are straight.

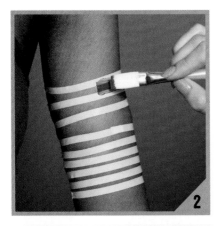

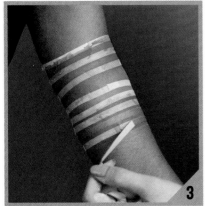

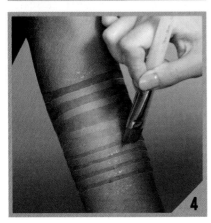

2. Use the 1" brush to apply the paint between the taped-off areas. Paint only in the areas where the skin is exposed between the first row of tape and the last row of tape.

3. Allow the paint to dry about 10 minutes, and then carefully pull off the tape.

4. Use the ½" flat brush to carefully apply glitter along the unpainted, exposed skin.

5. Allow the glitter to dry to the touch, about 5 minutes, then turn off the lights and turn on the UV lamp to show off your stripes proudly!

TATTOO TIPS

If you'd like to make this tattoo even more on trend, consider using a variety of colors to create an ombre effect. It's best to start out with different shades of one color. Start with the darkest shade with the first armband, and as you paint in each band switch to a lighter shade until you've painted in all of the lines.

Glow-in-the-Dark Blush

Makeup should always be a fun experience. You can use makeup to enhance your beauty or to make yourself look like a totally different person. But no matter how you choose to make yourself up, it's always a shame when your look isn't noticeable in the dark. After all, once the sun sets, the party starts. So, get the party started with a huge pop of Glow-in-the-Dark Blush!

MATERIALS

→→➤

* ⋆ UV lamp or bulb *(not pictured)*
* ⋆ 1 large blush brush
* ⋆ 1 (10-gram) container UV-activated pink glow powder

* * *

1. Turn on the UV lamp. Dip the brush into the glow powder and gently tap off the excess. Lightly dust the powder onto the cheeks starting from the apple of the cheeks and angling toward the ear. Act as though you are applying your normal everyday blush. You don't want to be heavy-handed, but do want to apply enough color so that it will still be noticeable during daylight.

2. Turn on the lights to make sure the blush looks blended and even during daylight. If one side looks pinker than the other, add more powder to even out the look. Remember, sometimes less is more. Work slowly and build up the color versus slathering on a bunch.

3. If you're happy with how the tattoo looks get ready to rock your fabulous blush day and night!

Nighttime Jewels

It's hard to flip through a magazine these days without seeing the words "statement necklace." And while it's true that these pieces can make an outfit, can you imagine wearing a chunky, clanking necklace when you're rocking out to some rad music? What's even worse is not being able to make the statement with your necklace when you're in the dark. But don't worry! These glowing Nighttime Jewels let you make a statement comfortably, no matter where you go.

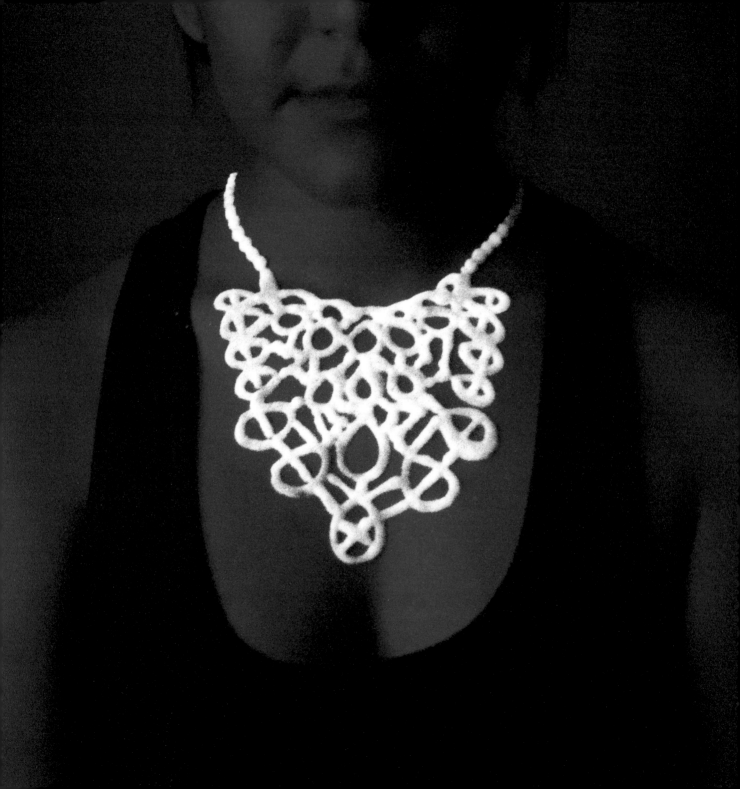

MATERIALS

➤

* Nighttime Jewels template (Appendix A) copied on an 8.5" × 11" sheet of paper *(not pictured)*

* 1 (9" × 12") piece wax paper

* 1 (4-ounce) bottle white glow-in-the-dark puffy paint

* 1 (0.37-ounce) vial cosmetic-grade yellow glitter

* Tweezers

* 1 (0.3-ounce) tube brush-on eyelash glue

* UV lamp or bulb *(not pictured)*

* * *

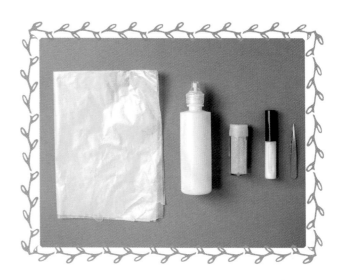

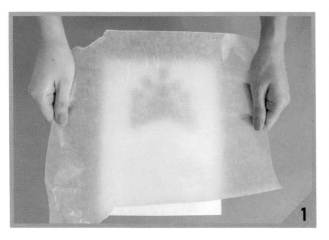

1

1. Lay the Nighttime Jewels template flat on a work surface and place the piece of wax paper over the image.

2. Use the puffy paint to outline the image by squeezing out a consistent line of paint about ⅛" thick. Take care not to apply too thin or thick of a line here: if the strip of puffy paint is too thin the necklace can easily break; if it is too thick it will take too long to dry. Feel free to add extra lines and dots to the tracing to give the necklace more detail. ▸

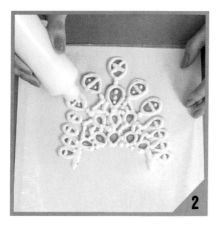

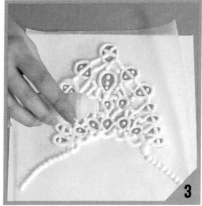

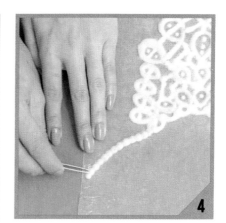

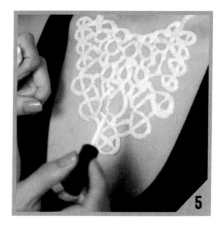

The lines can be connected to the original necklace (as I chose to do here) or they can be completely separate from the necklace. Just remember where you placed them so you can put them in the right spot on the skin later.

3. Before the paint dries, gently sprinkle yellow glitter over the necklace.

4. Set aside the necklace and let it dry for 24 hours. Once it is completely dry, use tweezers to carefully peel the puffy paint away from the wax paper.

5. To apply the necklace to the skin, place it along the neckline. Brush on some glue underneath the necklace and press down gently with your fingers. There is no need to glue the whole thing down; just feel for good anchoring points that will keep the necklace in place.

6. Since this is made with glow-in-the-dark puffy paint, the paint will get charged up when it is exposed to a UV light source or sunlight for 1–2 hours. Let your necklace charge up either by sunlight or a UV light and watch it glow in the night without a UV light source around. If you do catch yourself near a UV light source, don't be shy to step up to it. It will only make your necklace glow more intensely while it charges up for your next adventure.

TATTOO TIPS

Once you've mastered the Nighttime Jewels tattoo, you can use the same technique to create other types of necklaces from templates you find on your own. Look for a statement necklace template online and pick one that catches your eye. It's best to choose something with bold beads, gems, and findings so it is easy to trace out the image. Also, to give your necklace some life during the day, feel free to adorn it with gems or jewels or anything that you can make stick to it! Just because this project only calls for glitter it doesn't mean you shouldn't feel free to be creative.

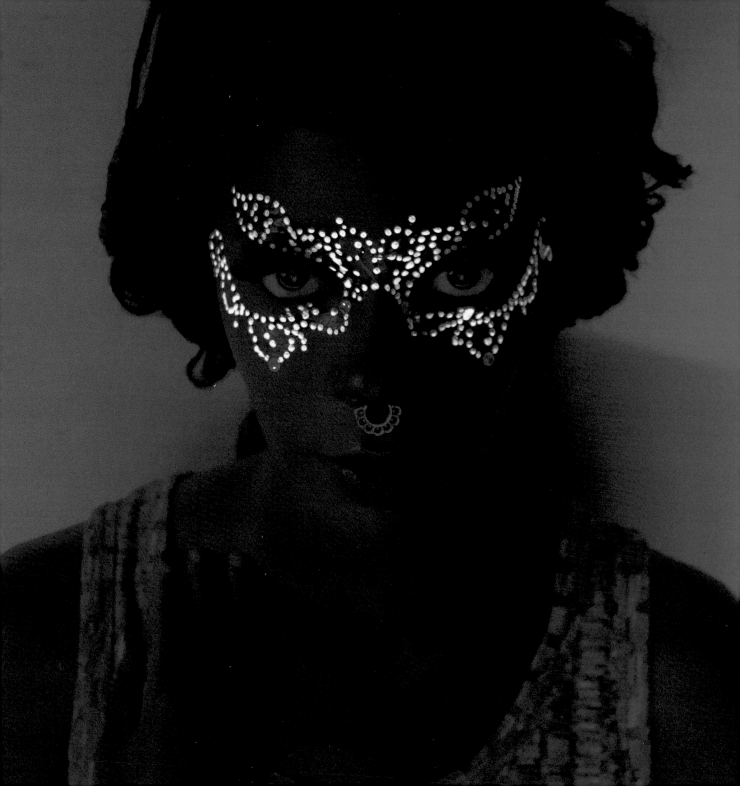

Masquerade

The idea of wearing a mask is to keep your identity unknown to the public. But while you may want your identity to be a secret, it doesn't change the fact that you still want to stand out. This glow-in-the-dark mask ensures that while everyone may be in the dark about who you are, you'll still be the star of the masquerade-themed ball!

MATERIALS

➤

* Masquerade template (Appendix A) *(not pictured)*
* 1 (8.5" × 11") temporary tattoo paper kit with a clear double-sided adhesive sheet *(not pictured)*
* Scissors
* 2–3 makeup wedges
* 1 (0.3-ounce) tube brush-on eyelash glue
* 2–4 (5 mm) clear rhinestones
* Tweezers *(not pictured)*
* 1 (2-ounce) bottle pink UV-activated paint
* 1 (1-ounce) applicator bottle with needle-tip cap (0.7–1 mm)
* UV lamp or bulb *(not pictured)*

* * *

1. Scan the Masquerade template into your printer and print on the shiny side of the tattoo paper. Lay the paper on a work surface with the image facing up and apply the clear adhesive sheet to the paper.

2. Cut out the mask and place it on the face to see how it fits. If the mask feels small around the eyes, feel free to trim out the holes for a better fit.

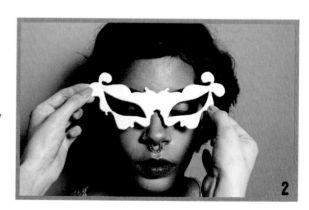

3. Cut the mask into three pieces: a top portion that fits across the eyebrows and comes down slightly on each side of the nose; and two bottom pieces that go under the eyes.

4. Peel off the clear backing from the top piece and apply it to the face along the eyebrows. Soak a makeup wedge in water and shake off excess. Gently dab the backing of the tattoo with the wedge until the paper is saturated. Carefully peel away the backing from the tattoo to expose the design.

5. Apply the lower pieces using the same method.

6. Use the brush of the eyelash glue to place a dot of glue to the inner corner of one eye. Pick up a rhinestone with the tweezers and place it on top of the glue. Press down gently until the rhinestone adheres. Repeat with the remaining rhinestones, placing one at the inner corner of the other eye and one on each cheekbone along the center of the bottommost points of the

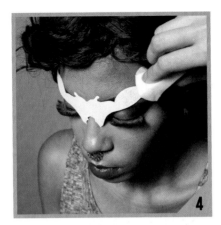

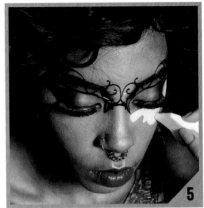

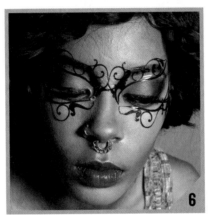

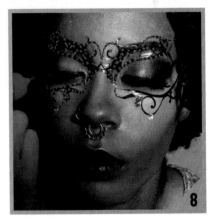

tattoo (or feel free to place the rhinestones wherever it looks best to you). Allow the glue to set about 10 minutes.

7. While the rhinestones are setting, pour the paint into the applicator bottle.

8. Apply little dots all along the outline of the tattooed mask. Be sure to avoid covering the whole mask because you want to be able to see it during the daytime. Allow the paint to dry to the touch, about 10 minutes. Then, turn off the lights and watch your mask glow!

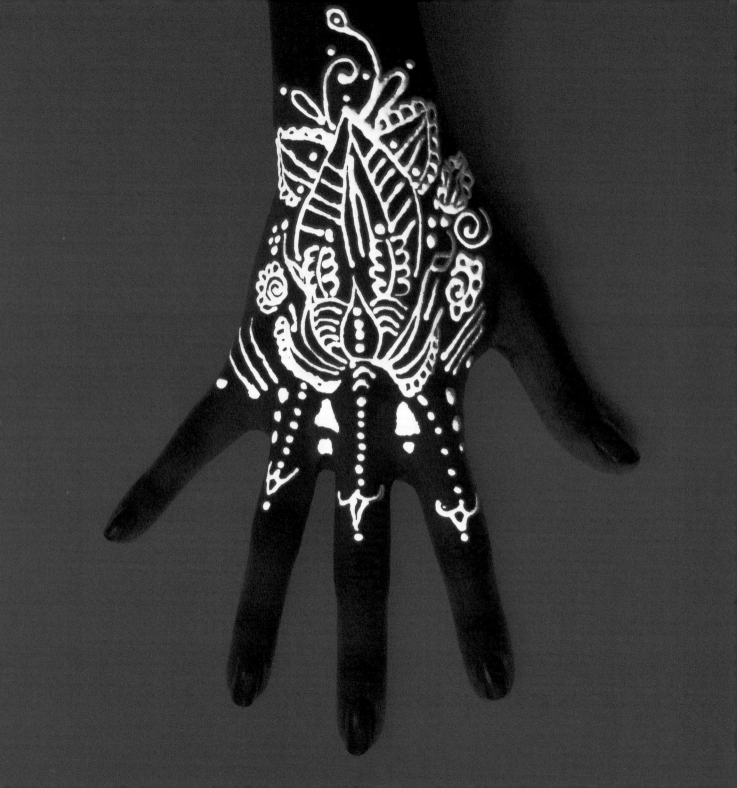

After-Dark Henna

Henna ink tattoos—which could possibly be the oldest form of temporary tattoos—have been worn by people all around the world as a way to adorn the body with a unique piece of art. But never before has henna had a chance to illuminate the night. Most have seen the traditional henna tattoo, some have seen white henna tattoos, and now you can easily see these tattoos with a glow-in-the-dark twist—whether the lights are on or off!

MATERIALS

* Scissors
* 1 (1-ounce) cone white henna ink
* 1 (1-quart) zip-top plastic bag
* 1 (5-gram) pot blue glow powder
* 1 (1-ounce) applicator bottle with needle-tip cap (0.7–1 mm)
* UV lamp or bulb *(not pictured)*

* * *

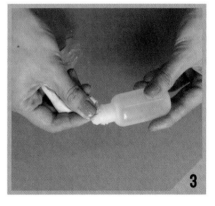

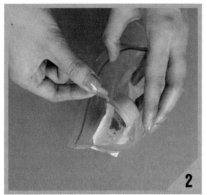

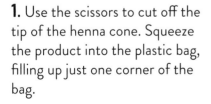

1. Use the scissors to cut off the tip of the henna cone. Squeeze the product into the plastic bag, filling up just one corner of the bag.

2. Pour 0.25 grams of the glow powder into the bag over the top of the henna. Seal the bag and use your hands to mix together the ink and powder until well combined. The mixture should be the consistency of pudding.

3. Use the scissors to cut off a corner of the plastic bag. Squeeze the mixture into the applicator bottle. Place the corner of the bag as far as possible into the bottle to avoid wasting any glowing henna.

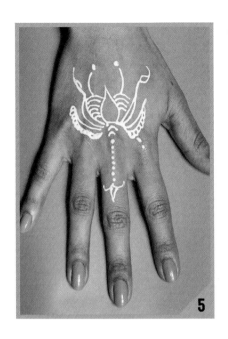

4. Test out the henna by squeezing a small dot onto a piece of scrap paper. Squeeze out 3–5 lines that are 3" long and ⅛" thick until you feel that you can confidently control the henna application process.

5. Carefully squeeze the applicator bottle and begin drawing out the henna image onto the back of the hand. Start by drawing a large design in the center of the hand. It can be a butterfly, a flower, or just a combination of lines and squiggles—there is no set design for this tattoo. Add fine details such as dots last. Continue adding details, working outward from the main design and extending up to the first knuckles of the fingers, until you are happy with the final result.

6. Let the henna set about 15 minutes or until it is dry to the touch. Turn on the UV lamp to charge the tattoo, or just go enjoy the daylight for an hour or so. Once it's dark and you have turned off the lights just watch your design glow!

TATTOO TIPS

For the best henna tattoo results, look online for the type of design you'd like to apply and practice drawing it on paper. Once you feel confident start applying the paint. This tattoo will glow under a UV light because of the white henna, but it will also glow without a UV lamp as long as the glow powder is charged up with light. When you're combining the henna and glow powder, be sure to mix well so there aren't any chunks.

Make a Statement

Life is about being bold, experiencing different things, and making moments that are memorable. And what's bolder than having glitter in different shapes across your shoulders or letting people see how confident you are with a large henna chest piece. And if people ask how you achieved these awesome looks, don't be afraid to tell them how simple these impressive tattoos really are—and how easy it is to razzle-dazzle them!

Statement Glitter

No matter your age, there's just something extremely fun about glitter. It's absolutely a necessity in everyone's craft box and now, with this Statement Glitter tattoo, you can add it to your cosmetic box too. The glitter-filled stars, butterflies, flowers, and more will make you sparkle on your way out the door—and why shouldn't you up your shine and dance the night away?

MATERIALS

→

* 1 (8.5" × 11") sheet printable white sticker paper
* 3–5 scrapbook paper punchers in a variety of sizes and shapes *(I used stars, butterflies, hearts, and flowers)*
* Scissors *(not pictured)*
* 1 (0.3-ounce) tube brush-on eyelash glue
* 2 (¼") angled brushes
* 4–6 (0.37-ounce) vials cosmetic-grade glitter in a variety of colors *(I used blue, purple, yellow, red, green, and pink)*

* * *

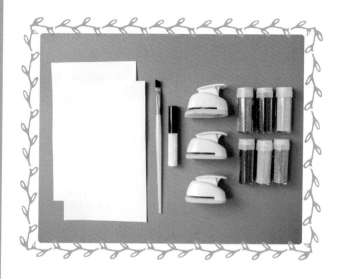

1. Lay out the sheet of sticker paper on a work surface. Use the paper punchers to punch out 1 row of each shape along the edge of the paper.

2. Use the scissors to cut the punched rows in strips; then cut the shapes into individual squares.

3. Choose an area to apply the tattoo, taking into account how many shapes you want to apply. (I picked the back of the shoulder.) Remove the backings of the stickers as you apply them to the skin.

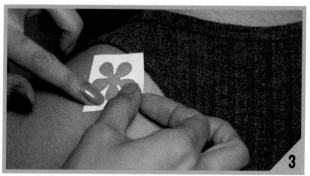

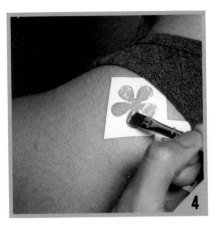

4. Use a brush to apply eyelash glue to the exposed skin inside the punched-out shapes.

5. Dip the other brush into one of the glitter colors and carefully brush it over the glue. Cover the glue completely with glitter and then remove the sticker paper immediately. You don't want the glue to dry completely; if it is too tacky when you remove the sticker paper the shapes will get distorted.

6. Repeat steps 4–5 with the remaining glitter colors, filling in all the sticker squares. Head out to rock this look!

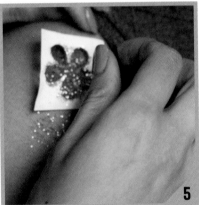

TATTOO TIPS

When choosing the hole punches that you'll use to create the shapes for this tattoo, be sure to pick outlines that aren't too intricate. The glue and the glitter won't capture the details of more intricate details.

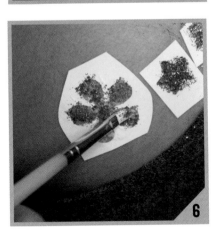

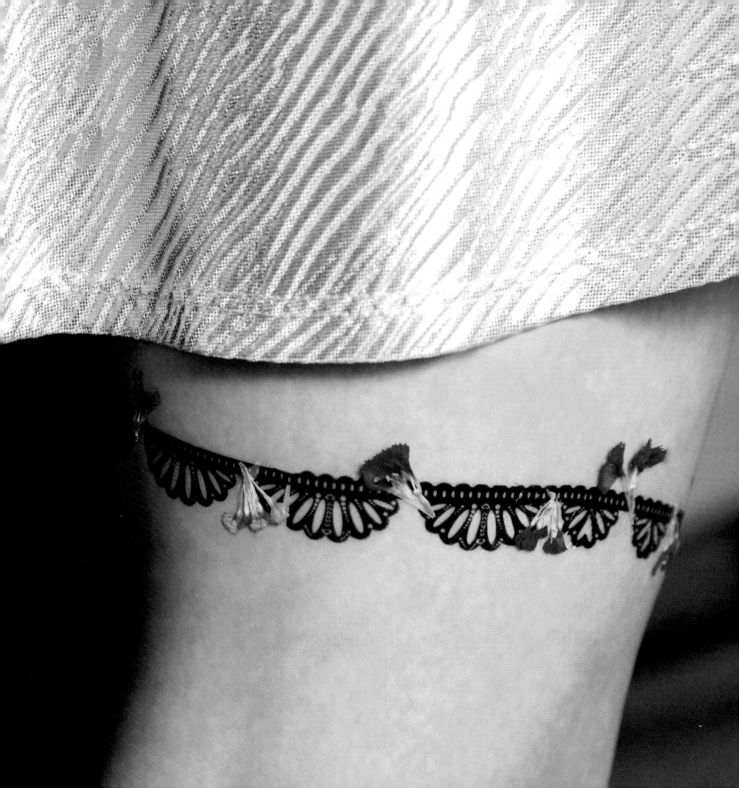

Visible Garter

The garter. Whether worn by brides as part of their wedding attire or by bad girls exuding a seductive air, this accessory always makes the imagination work overtime. But garters can be uncomfortable and there's nothing sexy about constantly pulling them back up. Enter this super-hot Visible Garter tattoo. It's sweet, sensual, and guaranteed to catch the eye, all while leaving you with one less thing to fuss with when you head out for the night.

MATERIALS

———➤

* 1 Visible Garter template (Appendix A) *(not pictured)*
* 1 (8.5" × 11") temporary tattoo paper kit with a clear adhesive sheet
* Scissors
* 1–2 makeup wedges
* 1 (0.3-ounce) tube brush-on eyelash glue
* 10–15 dried and pressed sweet William petals and leaves *(see the Pressed Flowers tattoo project in Chapter 2)*

* * *

1. Scan the Visible Garter template into your printer and print on the shiny side of the tattoo paper. Note: Be sure to print multiple templates so you can fit them around the thigh. Keep in mind that the pattern doesn't have to look too intricate.

2. Peel the paper backing off the adhesive sheet and, with the lace image facing up, apply the tacky side of the adhesive sheet to the lace images.

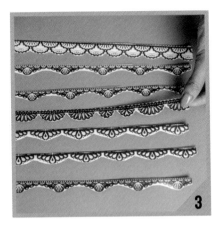

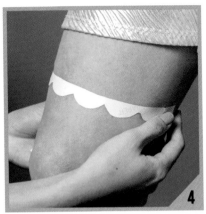

3. Use the scissors to carefully cut around the images.

4. Remove the clear film from the temporary tattoo and apply it to the thigh. Press gently but firmly so it sticks to the skin.

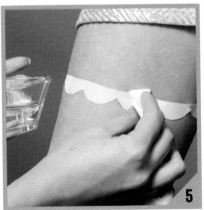

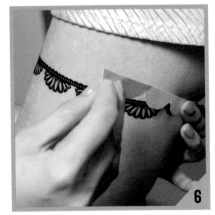

5. Soak a makeup wedge in water and shake off excess. Gently dab the backing of the tattoo with the wedge until the paper is saturated. Carefully peel away the backing from the tattoo to expose the design.

6. Repeat with additional lace pieces until the thigh is encircled.

7. Use the brush of the eyelash glue to place dots of glue between two scallops of the garter. Carefully place a pressed flower on top of the glue. Press down gently until the flower adheres.

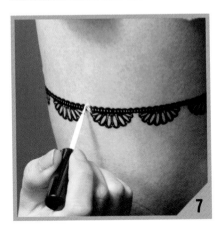

8. Repeat with remaining flowers and leaves. Allow the glue to set about 10 minutes before wearing the garter out!

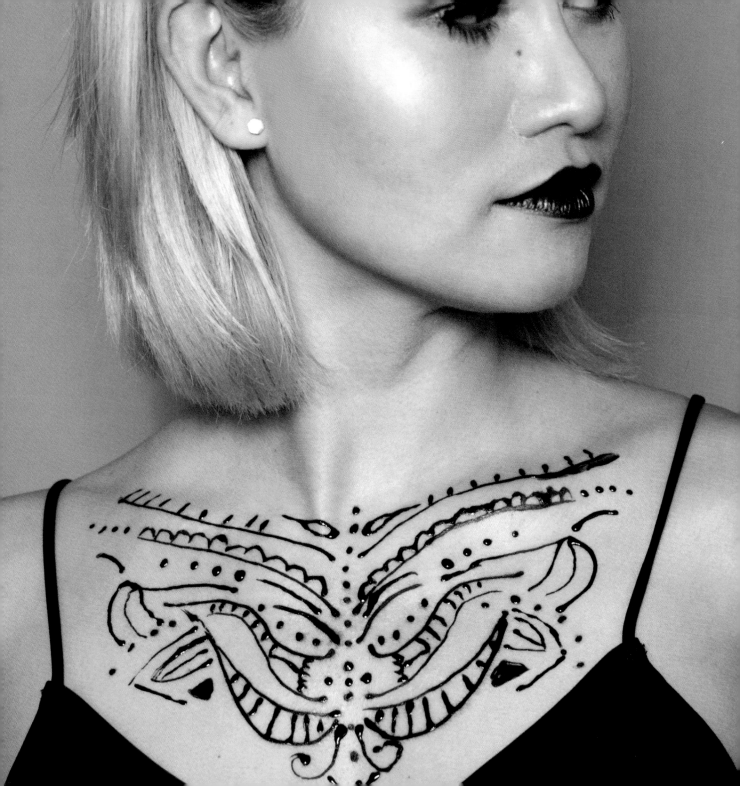

Large Henna Chest Piece

The décolletage of a woman can be one of the sexiest and most alluring characteristics of feminine beauty. Throughout history, women were either covering it up to show decency and virtue or showing it off for fashion and wealth. Either way, the décolletage has always been a focal point in fashion. If you decide to show it off, be sure to make a statement with this amazing Large Henna Chest Piece. Talk about being bold!

MATERIALS

* **Scissors** *(not pictured)*
* 1 (1-ounce) cone red henna ink
* 1 (1-ounce) applicator bottle with needle-tip cap (0.7–1 mm)

* * *

1. Use the scissors to cut off the tip of the henna cone and squeeze the ink into the applicator bottle.

2. Test out the henna by squeezing a small dot onto a piece of scrap paper. Squeeze out 3–5 lines that are 3" long and ⅛" thick until you feel that you can confidently control the henna application process.

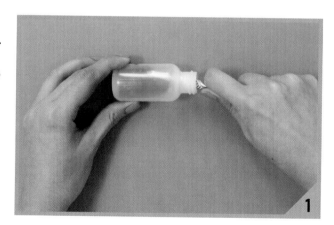

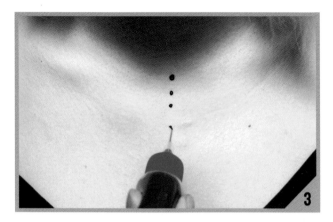

3. Squeeze the applicator bottle and add a vertical line of dots running down from the center of the collarbone to just above the cleavage. You should expect to add about 10–15 dots.

4. Next, draw two long lines along each collarbone. Continue adding larger designs, mirrored on each side of the original line of dots. Use the body as a guide and let it tell you where to add additional henna markings.

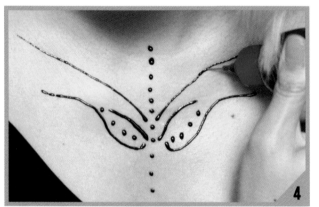

5. After you are done with the larger designs, add dots and vertical lines around or inside any of the shapes to add detail.

6. Allow the henna to dry for 1 hour or until you see some of the henna flaking off on its own. It should be dry to the touch. Then enjoy your artwork for up to 3 weeks! If the henna does not flake off with gentle brushing, it usually means it hasn't dried all the way through. Give it another 10 minutes of drying time.

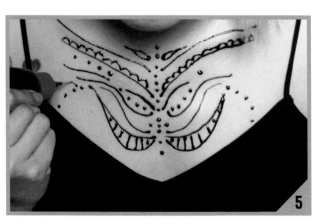

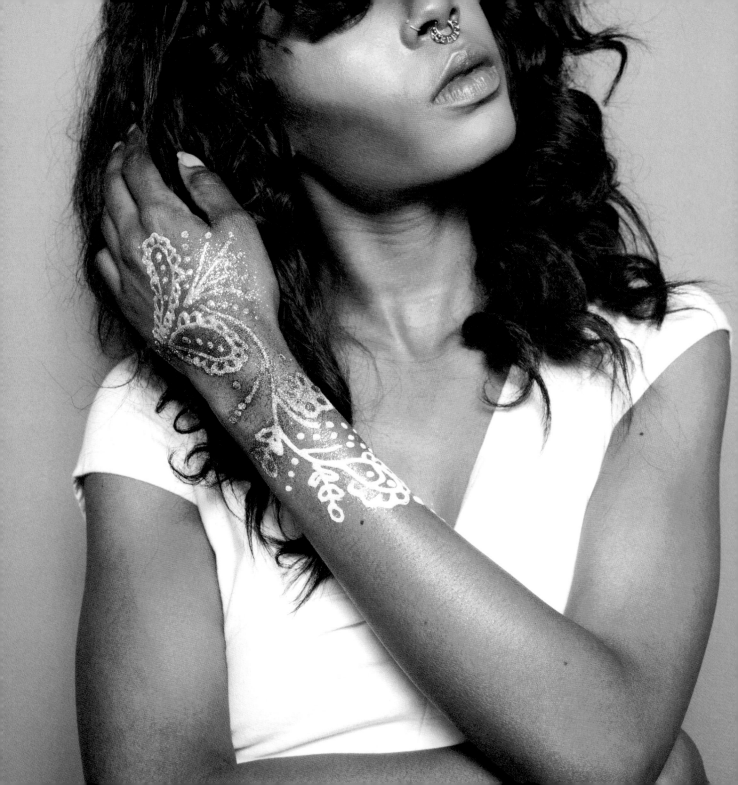

Metallic Henna Jewelry

You can do a lot with henna ink tattoos, but if you love glitter and simple floral designs, there is no reason that you shouldn't light up the night with an armful of this sparkling Metallic Henna Jewelry. If you'd like, feel free to add a little glow powder to it and really make a statement!

MATERIALS

➤

* Scissors

* 1 (1-ounce) cone white henna ink

* 1 (1-ounce) applicator bottle with
 needle-tip cap (0.7 mm–1 mm)

* 3 (0.37-ounce) vials cosmetic-grade
 glitter (I used blue, magenta, and yellow)

* * *

1. Use the scissors to cut off the tip of the henna cone. Pour the ink into the applicator bottle.

2. Test out the henna by squeezing a small dot onto a piece of scrap paper. Squeeze out 3–5 lines that are 3″ long and ⅛″ thick until you feel that you can confidently control the henna application process.

3. Take the henna ink and use it to draw a paisley leaf about 3″ in length on the back of the hand, starting about an inch below the first finger and extending down below the pinky, near the edge of the hand.

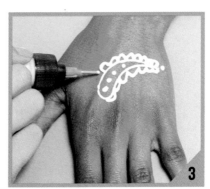

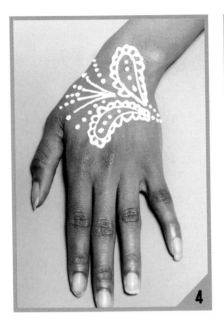

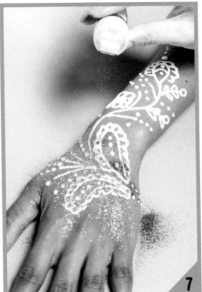

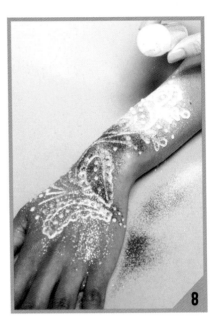

4. Next, use the ink to create a mirror image of the first paisley, extending up to the knobby bone on the wrist. Draw 3–4 lines radiating from the center of the leaves and add dots above each line and along the sides of the outermost lines.

5. Continue adding lines, dots, and additional leaves following the pattern up the wrist to around the forearm. When done, the completed designs should crawl up to the forearm about 6–9".

6. Gently sprinkle the blue glitter over the henna design, stopping when you reach the wrist.

7. Transition to the magenta glitter, and sprinkle a little over the top of the last portion of blue glitter; continue up another 2–3" of the design.

8. Lastly, take the yellow glitter and gently sprinkle some on top of the area where the pink ended; continue sprinkling it along the rest of the exposed white henna.

9. Let dry for 20 minutes. Once dried, shake off any excess glitter. Then, let this amazing Metallic Henna Jewelry speak for itself!

Wild Kingdom

Zebras and unicorns and sparrows, oh my! The animal kingdom is large, dynamic, and totally on trend. How many times have you seen an animal pattern printed on fabric? Or even fabricated antlers and horns hung on the wall as part of the decor? Let's be real here: Animals—both real and imaginary—are always ahead of the game as far as style is concerned. In this chapter you'll find a variety of super-cool temporary tattoos that bring these majestic beasts to life on your own skin—and cement your role as part of the animal kingdom!

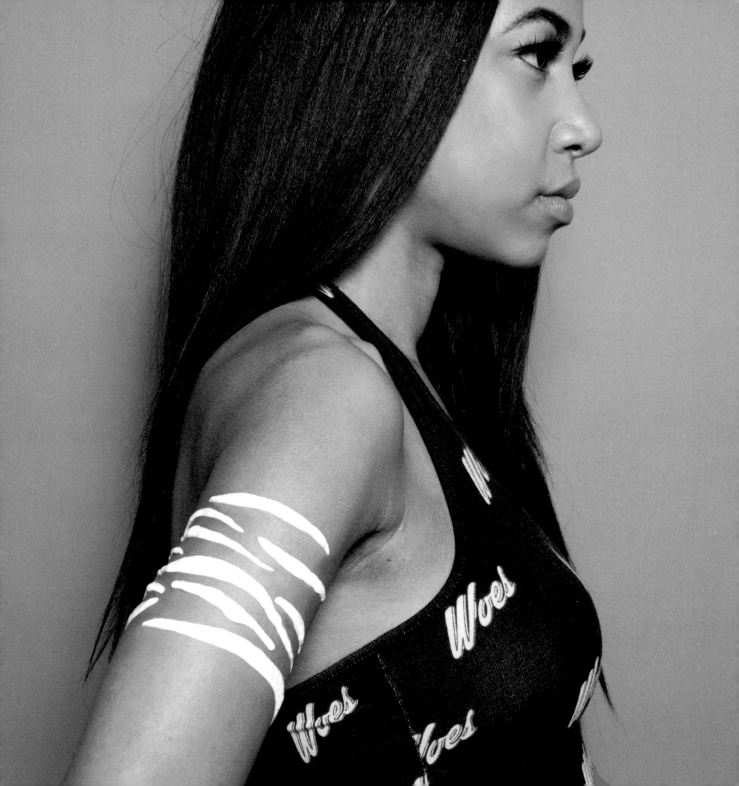

White Henna Zebra

Temporary tattoos are a great way to share your unique style and individuality with others, whether you're rocking out at a music festival or walking down the street on a random Saturday. And nothing is more unique and individualized than the black and white stripes of a zebra. So grab some white henna, apply your tattoo, and show off your own individuality by rocking some zebra stripes!

MATERIALS

---→

* 1 nontoxic temporary tattoo pen
* Scissors
* 1 (1-ounce) cone white henna ink

* * *

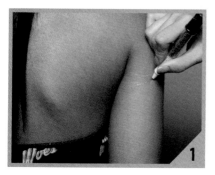

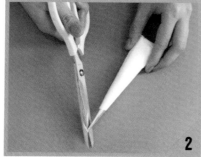

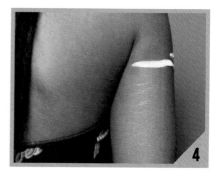

1. Use the tattoo pen to draw zebra stripes onto a 4–5" section of the upper arm: Starting from the top of the arm, draw a squiggle, and right below that squiggle (about ½" down), draw another squiggle that is exactly the same, making sure that the ends of the squiggles meet up to a point. Repeat, creating 6–8 stripes going in opposite directions.

2. Use the scissors to cut off just the tip of the henna cone. Be careful not to cut off too much of the tip; otherwise too much henna will come out.

3. Test out the henna by squeezing a small dot onto a piece of scrap paper. Squeeze out 3–5 lines that are 3" long and ⅛" thick until you control the henna application process.

4. Squeeze the henna cone gently and outline the first stripe at the top of the design. Then fill it in with the white henna. Repeat with the other stripes, moving from top to bottom to avoid smudging.

5. Once you've filled in the stripes, wait at least 30 minutes for the henna to dry to the touch.

Rainbow Sparrows

Have you ever looked up at the birds and wondered what they are thinking as they dart across the sky? Do you envy their graceful way of cutting through air and wish you could do the same? Well, you're probably not going to sprout wings anytime soon but with this Rainbow Sparrows tattoo, you can absolutely share in the joy of these winged creatures!

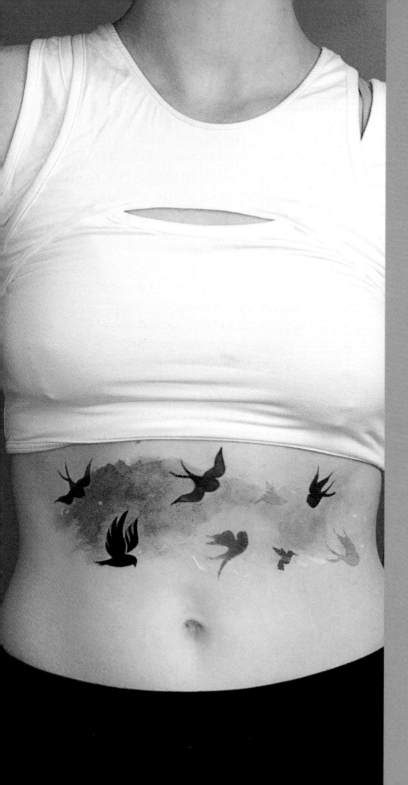

MATERIALS

* 2 (3.6-gram) packages artificial drink powder *(I used blue and red)*

* 2 small glass bowls

* 4 tablespoons water, divided *(not pictured)*

* 1 small spoon *(not pictured)*

* 2 (⅛") round brushes

* 1 Rainbow Sparrows template (Appendix A) *(not pictured)*

* 1 (8.5" × 11") sheet tattoo paper with a clear adhesive sheet *(not pictured)*

* Scissors

* 2–3 makeup wedges *(not pictured)*

* 1 white liquid eyeliner pen *(not pictured)*

* * *

1. Pour 1 package of drink mix into each of the glass bowls and add 2 tablespoons of water to each bowl. Use a spoon to mix and dissolve the powder into the water.

2. Dip a brush into the red mixture. Then, paint the mixture onto the right-hand side of the upper abdomen (right above the bellybutton) using a sweeping motion to create strokes going up and down about 3–5" covering about half of the upper abdomen.

3. Take the second paintbrush and dip it into the blue mixture. Then, starting where the red paint left off, apply the mixture using up-and-down strokes about 3–5" in width until you reach the left side of the upper abdomen.

4. Dip the brush into a little bit of water and dab it on the spot where the colors meet to blend the seam. Now, allow the mixture and the water to dry about 1–2 minutes. ▸

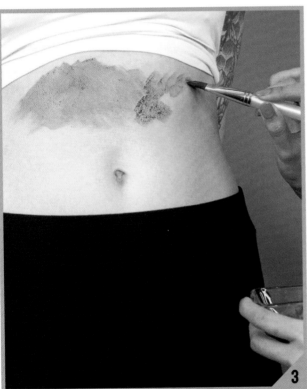

 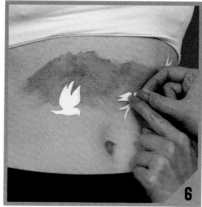 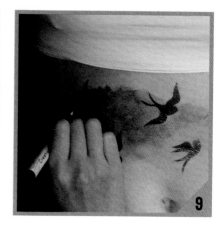

5. Scan the Rainbow Sparrows template into your printer and print onto the shiny side of the tattoo paper. Peel the paper backing from the adhesive layer and apply the sticky side of the adhesive layer to the printed tattoo paper with the sparrow image facing up. Use the scissors to cut out the sparrows as neatly as possible. The cleaner the cut the better the tattoo will look!

6. Peel the clear film off of each sparrow. Starting from the outermost part of the abdomen where the red starts, apply a sparrow to the skin. Continue adding sparrows along the red, and moving on by adding sparrows into the blue. You don't want static-looking sparrows, so as you apply them, be sure to rotate them so it looks like they are darting around in the sky.

7. Soak a makeup wedge in water and shake off excess. Gently dab the backing of the tattoos with the wedge until the paper is saturated, being careful to only touch the tattoo paper and not the area where the skin has been painted. Carefully peel off the backing from the tattoos to expose the design.

8. Some of the drink mix might have been removed from the application of the sparrows. Go back with a brush and some water to reblend the colors of the drink mix. Allow the skin to dry about 10–15 minutes before moving on to the next step.

9. Use white liquid eyeliner to add 10–15 dots inside the painted areas to add whimsy to the look. Most liquid liners usually dry right after application but just to be safe, give it 5 minutes to dry before heading out the door!

Metallic Unicorn Horn

A unicorn is traditionally depicted as a woodland creature with shy and timid characteristics that make it difficult to capture. Legend has it that the only person who can catch a unicorn is a fair maiden, but if you're not interested in catching this horned beast, you can join him in his ephemeral realm by donning his most amazing feature: the golden spiraled horn that protrudes from his head. It's an accessory so iconic that no one who sees this Metallic Unicorn Horn could mistake it for anything else.

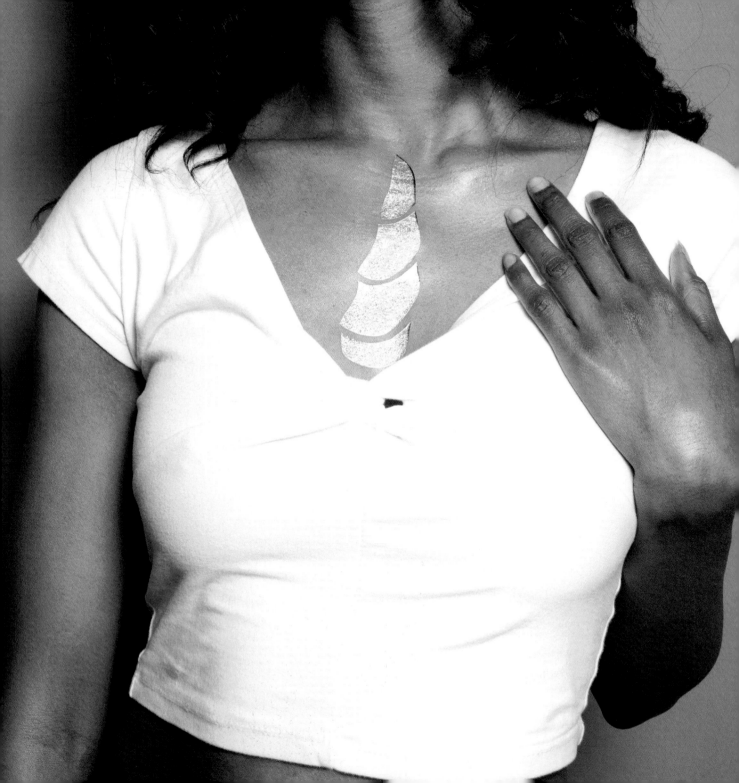

MATERIALS

* Metallic Unicorn Horn template (Appendix A)
* 1 (8.5" × 11") temporary tattoo paper kit with a clear adhesive sheet
* Scissors or craft knife
* 1 (3.15" × 3.15") sheet gold leaf
* Pen *(not pictured)*
* 2–3 makeup wedges

* * *

1. Scan the Metallic Unicorn Horn template into your printer and print on the shiny side of the tattoo paper. Then, print the mirror image on the other side of the tattoo paper as a guide for later.

2. Use the scissors to cut out 2 pieces of adhesive paper that are about the same size as the unicorn horn.

3. Remove the paper backing from one of the cut pieces of adhesive and place it sticky side down on the shiny side of the tattoo paper.

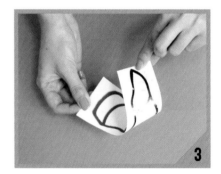

4. Peel off the clear film from the adhesive paper to reveal the sticky side of the adhesive, then place the sticky side on the gold leaf sheet. Gently press down to smooth out the horn and to ensure that the gold sheet is sticking to the adhesive. ▸

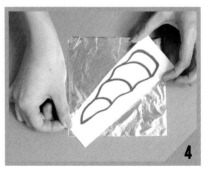

5. Take the second piece of cut adhesive paper and peel off the clear film. Place the adhesive paper down with the sticky side facing up. Take the unicorn horn with the gold leaf on it, and stick the gold leaf onto the adhesive. Gently press down to make sure that the adhesive sticks to the gold sheet.

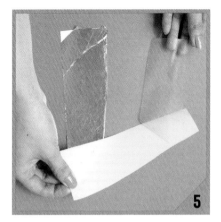

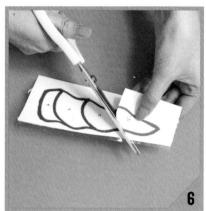

6. Next, flip the tattoo over and number each section in the spiral on the unicorn horn so you don't forget the order to apply it. Then, use the scissors or craft knife to cut out each spiral of the horn, being sure to cut inside the lines.

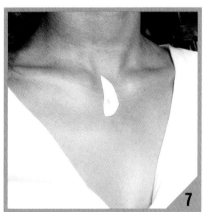

7. Peel the clear film off of the top piece of horn, then apply it to the skin right between the collarbone.

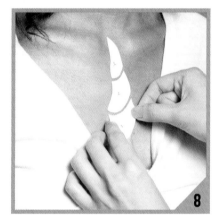

8. Repeat the previous instructions to apply the remaining pieces of horn in order.

9. Soak a makeup wedge in water and shake off excess. Gently dab the backing of the tattoos with the wedge until the paper is saturated. Carefully peel away the backing from the tattoos to reveal the metallic horn. Wipe up any extra water that might be on the tattoo or skin and get ready to prance around and show off this new unicorn horn!

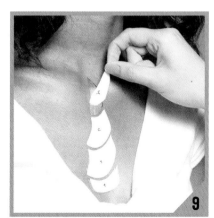

Low-Poly Tissue Paper Fox

You've heard the saying "sometimes less is more"? Well, it's true. Sometimes, expressing something is more important than the intricate details of it. That's what low-poly art—when you take out all the details from a subject and still maintain the characteristics of what you are trying to portray—is all about! This Low-Poly Tissue Paper Fox allows you to show off your fierceness . . . while keeping things low-key.

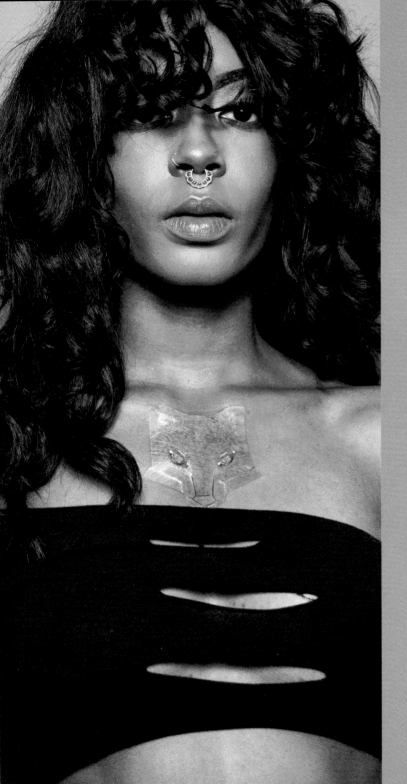

MATERIALS

* 1 sheet pink tissue paper

* Low-Poly Tissue Paper Fox template (Appendix A)

* Pencil

* Scissors

* 1 (8.5" × 11") temporary tattoo paper kit with a clear adhesive sheet *(not pictured)*

* 1 (¼") flat brush

* 1 (1-ounce) container silver cosmetic-grade metallic powder

* Craft knife *(not pictured)*

* 1–2 makeup wedges

* 1 (0.3-ounce) tube brush-on eyelash glue

* 2 (½") pink navette-shaped rhinestones

* * *

1. Place the tissue paper on the Low-Poly Tissue Paper Fox template and use a pencil to trace the image onto the tissue paper.

2. Use the scissors to cut the clear adhesive sheet into 2 pieces that fit over the fox image. Set this aside for now.

3. Use the scissors to carefully cut the image out of the tissue paper. It's best to cut out the whole image, and then cut out the smaller pieces such as ears, nose, and mouth. Some pieces might be too small to cut out. If this is the case, leave those pieces attached as needed.

4. Remove the paper backing from the adhesive sheet and adhere to the shiny side of a piece of tattoo paper.

5. Remove the clear film from the adhesive and carefully arrange the tissue paper shapes on the adhesive as they were in the original image.

6. Dip the brush into the metallic powder, and fill in any of the gaps where the adhesive is still exposed within the image.

7. Take the second sheet of adhesive paper and remove the clear film to expose the sticky surface. Take the fox image, place it face-down on the adhesive paper, and press gently to smooth out any bubbles. ▸

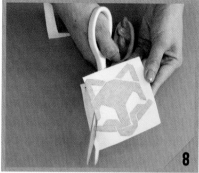

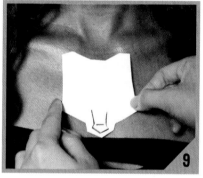

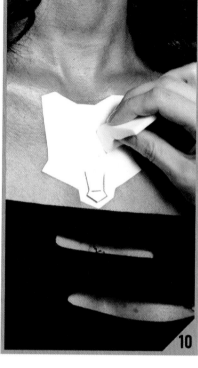

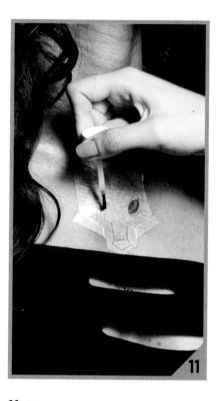

8. Use the scissors to cut around the fox as closely as you can to the tissue paper to remove any of the excess adhesive. For more intricate details such as around the nose of the fox, use a craft knife to carefully cut out the outline.

9. Remove the clear film from the tattoo paper to expose the sticky adhesive and press the design firmly onto the sternum.

10. Soak a makeup wedge in water and shake off excess. Gently dab the backing of the tattoo with the wedge until the paper in saturated. Carefully peel away the backing from the tattoo to expose your fox. Wipe up any excess water that is on the tattoo or around the skin and allow the skin and tattoo to dry thoroughly, about 5 minutes.

11. Next, use the brush of the eyelash glue to place a dot of glue on one of the fox's eyes. Then take a rhinestone and place it on top of the glue. Press down gently until the rhinestone adheres. Repeat with the remaining rhinestone to give the fox two glittering eyes.

12. Allow the rhinestones to set about 5 minutes before heading out, ready to howl at the moon!

Delicate Feathers

Birds naturally molt their feathers once or more a year, but a perfectly preserved feather is still a hidden treasure, which is exactly what this Delicate Feathers tattoo will be. Traditionally the color of the feather has a symbolic meaning. For example, a white feather represents angels, faith, protection, purification, and hope; a black feather represents wisdom, protection, and spiritual growth. I chose black feathers for this project, but feel free to choose whichever color feels right for the day.

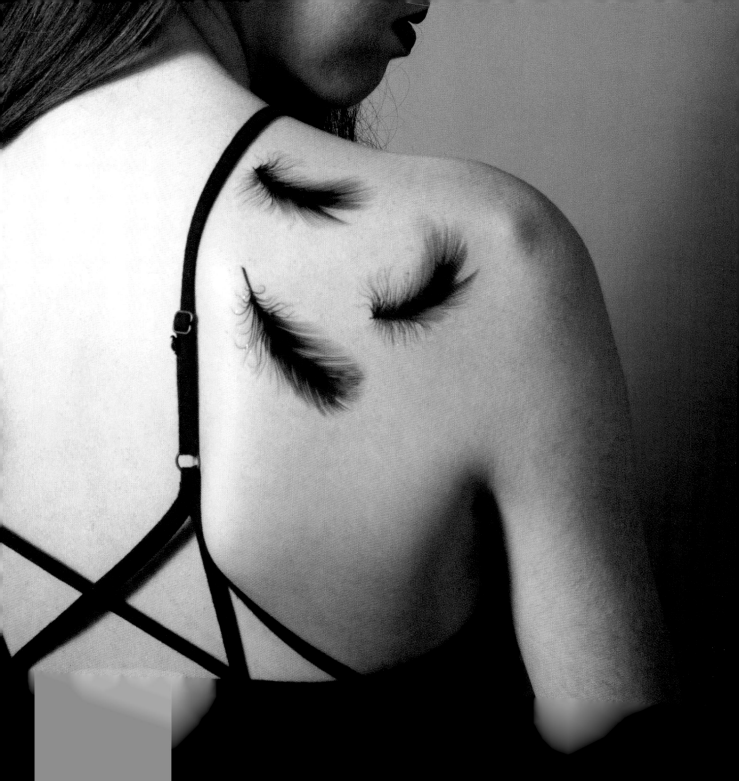

MATERIALS

* Delicate Feathers template (Appendix A)
* 1 (8.5" × 11") temporary tattoo paper kit with a clear adhesive sheet (*not pictured*)
* Scissors
* 1–2 makeup wedges

* * *

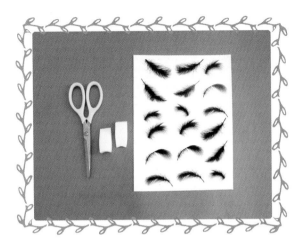

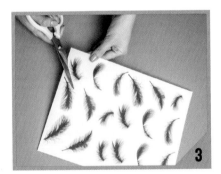

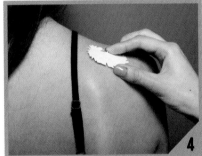

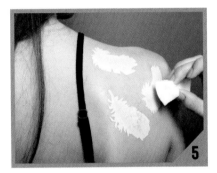

1. Scan the Delicate Feathers template into your printer and print on the shiny side of the tattoo paper.

2. Take the adhesive sheet that came in the tattoo paper kit and peel off the paper. Then carefully attach this sheet to the shiny side of the tattoo paper. Press gently to remove any air bubbles.

3. Use scissors to carefully cut out 3–5 feather images.

4. Peel off the clear film from each feather tattoo and press it gently onto the skin of the shoulder blade, covering the whole shoulder. Be sure to position all the feathers 1–2" apart, as though they are falling gently from the sky.

5. Soak the makeup wedge with water and shake off excess. Gently dab the backing of the tattoos with the wedge until the paper is saturated. Carefully peel away the backing from the tattoos to expose the feathers and head out the door to show off these beautiful, cascading Delicate Feathers.

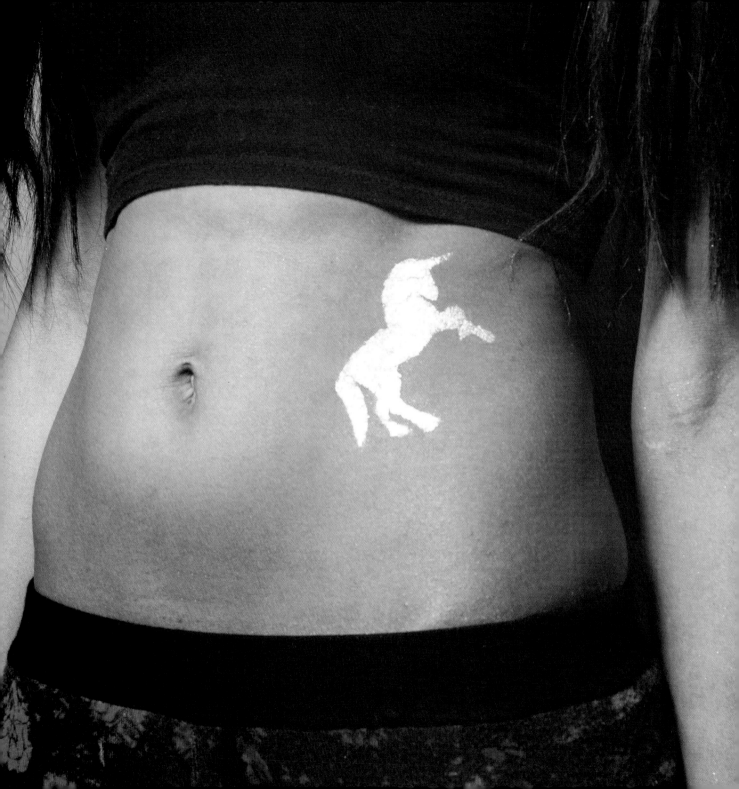

Glitter Unicorn

You learned how to grab attention with the Metallic Unicorn Horn tattoo earlier in this chapter, but now it's time to amp up the shine and add glitter to the equation. With this Glitter Unicorn tattoo, instead of highlighting the horn, you're showcasing this ephemeral beast in all its glory—and putting your own glory front and center to boot!

MATERIALS

* Glitter Unicorn template (Appendix A)
* 1 (8.5" × 11") sheet printable sticker paper *(not pictured)*
* Scissors
* Craft knife
* 1 (1-ounce) bottle liquid bandage
* 1 (⅜") flat brush
* 1 (1-ounce) tub gold cosmetic-grade ultrafine metallic glitter *(Note: Not all of this will be used.)*

* * *

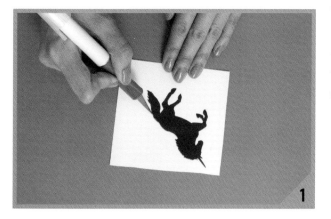

1. Scan the Glitter Unicorn template into your printer and print on the sticker paper. Then use scissors and a craft knife to cut around the image taking care to not cut through the edges of the stencil.

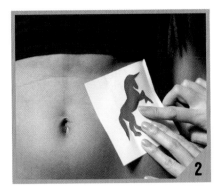

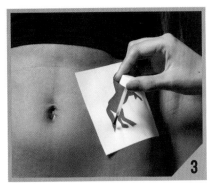

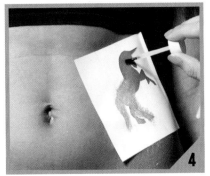

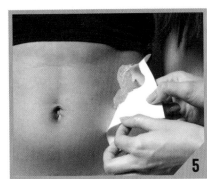

2. Peel the paper backing away from the unicorn cutout and adhere the sticky side to a flat area of the skin. I chose to place it on the abdomen, off to one side just above the hipbone.

3. Apply liquid bandage on the exposed skin inside the stencil.

4. Dip the brush into the glitter and apply it over the liquid bandage to cover. Keep applying glitter until you can pat it with your fingers and can no longer feel any tackiness from the liquid bandage.

5. While the liquid bandage is still tacky, gently pull off the sticker stencil to reveal the image and show off your shine!

CHAPTER 6

Shine Bright

Reaching for the stars means to strive for something great—to do something that's totally out-of-this-world. That is a perfect description for the temporary tattoos in this chapter! Here you'll learn how to draw the night sky on your back. You will be able to broadcast your astrological sign to your potential soulmate without saying a word. And if that's not enough, you'll learn how to light up an intergalactic galaxy on your skin with a simple dusting of glow powder. So if you are ready to shine bright, there's no need to reach for the stars. All you have to do is turn the page.

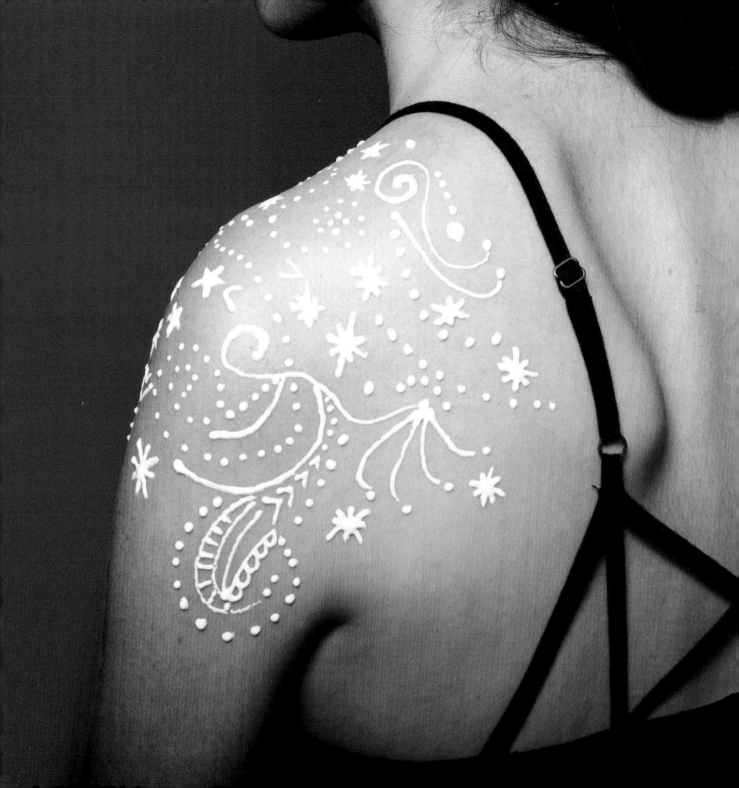

White Sparkling Stars

There is nothing as simple, complex, and beautiful as the dark canvas of the night sky accented with twinkling stars. Bring that beauty with you wherever you go with the henna ink used in this project. And if you're looking for something simple, this tattoo is easy to tackle as long as you can draw asterisks and dots. So grab some ink and get ready to bring the night sky in.

MATERIALS

* * *

* Scissors
* 1 (1-ounce) cone white henna ink
* 1 (1-ounce) applicator bottle with needle-tip cap (0.7–1 mm)

* * *

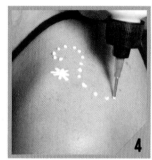
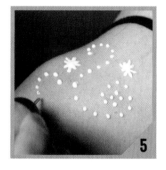
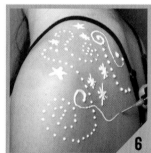

1. Use the scissors to cut off the tip of the henna cone and squeeze the ink into the applicator bottle.

2. Test out the henna by squeezing a small dot onto a piece of scrap paper. Squeeze out 3–5 lines that are 3" long and ⅛" thick until you feel that you can confidently control the henna application process.

3. Use the applicator bottle to draw a small asterisk about ⅜" in diameter at the top of the shoulder (or wherever you choose to place the tattoo).

4. About ½" away from the asterisk add a series of dots that resemble a backward S shape. End the dots with another asterisk.

5. Create swirls with a line of dots surrounding the asterisk on the shoulder.

6. Continue to add a variety of swirls, dots, and curves to create a dynamic pattern for the design. Once you're satisfied with the design, allow the henna to dry about 15–20 minutes or until dry to the touch, and you can be on your way!

Glowing Constellations

Sometimes you wonder what your destiny in life might be. Other times you open up a magazine and read your horoscope in astonishment. Now, who's to say that you shouldn't believe what is written in your horoscope? After all, if your destiny is written in the stars, wouldn't it be easier to figure out what it is at night? So, let's make sure that you can always see the stars by using glowing paint! Who knows, it might make it easier for your perfect match to spot you.

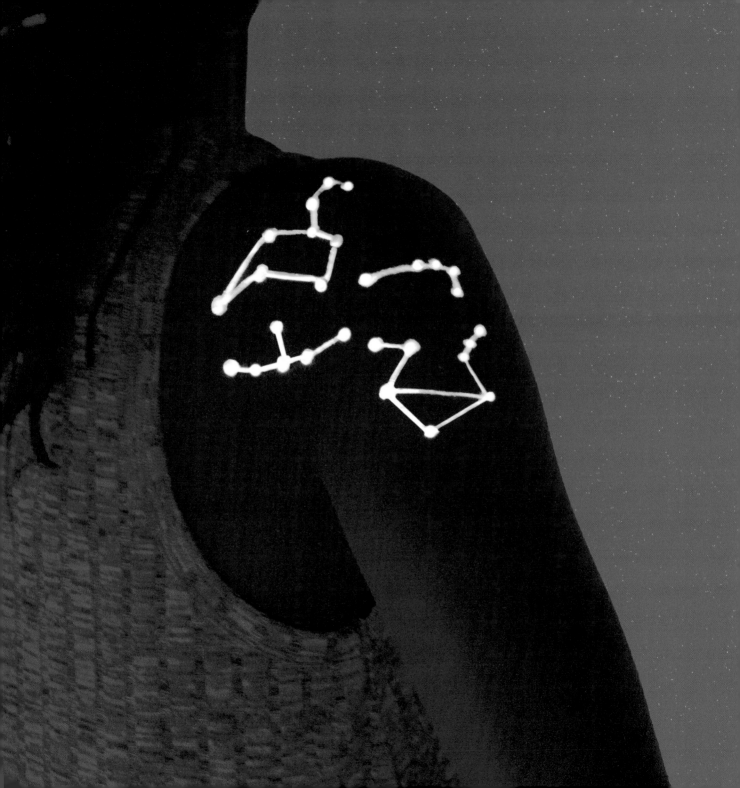

MATERIALS

* 1 (0.5-ounce) tube yellow UV-activated paint
* 1 (1-ounce) applicator bottle with needle-tip cap (0.7–1 mm)
* Scissors *(not pictured)*
* Glowing Constellations template (Appendix A) copied onto an 8.5" × 11" piece of printer paper
* 1 silver nontoxic temporary tattoo pen *(Note: It's best to pick a color that matches your paint or cannot be seen under the paint.)*
* UV lamp or bulb *(not pictured)*

* * *

1. Pour the paint into the applicator bottle.

2. Use the scissors to cut around each constellation on the template as closely as possible. Use the tip of the applicator bottle to poke a hole through each star point on the constellation. Position the constellation stencil on the back of the shoulder (or wherever you decide to place the tattoo) and press the pen through each star point, leaving the pattern on the skin. Set the stencil aside then repeat with any remaining stencils that you choose to use. ▸

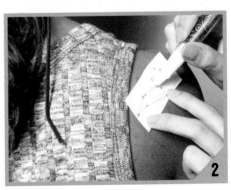

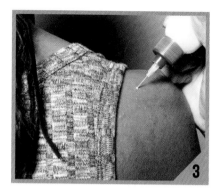

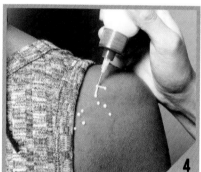

3. Use the applicator bottle to squeeze dots of paint on the pen marks. Keep in mind that each dot should be similar in size. It's best to squeeze the bottle until you see a bead of paint, then use that bead to dot the pen marks. Once you've added the paint to all the dots let it dry to the touch, about 3–5 minutes.

4. Take the constellation stencil that you set aside in step 2 and use it as a guide to see how you should connect the dots that you added in the previous step. Take the applicator bottle and add thin, consistent lines of paint between the dots.

5. Let the paint dry to the touch for about 10–15 minutes, then turn on a UV lamp to see the constellation shine!

TATTOO TIPS

If you'd like to add some extra sparkle around your constellations, use a gel-based silver glitter and apply it around your work. You can easily use your index finger to spread the glitter. Give the glitter 5 minutes to set and the paint an extra 10 minutes to dry before heading out.

Golden/Silver Stars

Stars have such a huge significance in our society. We look at their patterns to predict what will happen to our universe. We use them to tell mythological stories. We wish upon them. It's no wonder that stars have become one of the most popular tattoo designs. This project cradles the stars in a golden crescent moon and will make all your wishes come true.

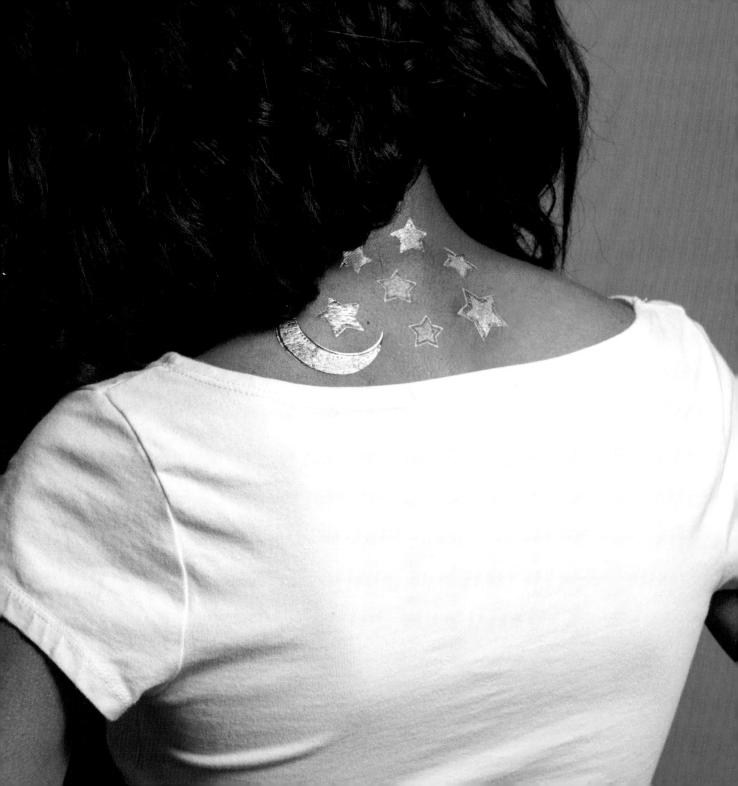

MATERIALS

* Golden/Silver Stars template (Appendix A)
* 1 (8.5" × 11") temporary tattoo paper kit with a clear adhesive sheet (not pictured)
* Scissors
* 1 (8.5" × 11") additional piece clear double-sided adhesive paper
* 1 (3.15" × 3.15") sheet gold leaf
* Craft knife
* 1–2 makeup wedges

* * *

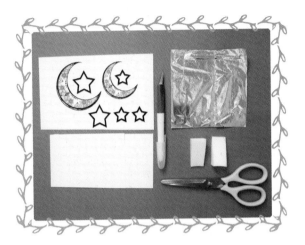

1. Scan the Golden/Silvers Stars template into your printer and print on the shiny side of the tattoo paper. Then print the mirror image on the other side as a guide for later.

2. Use your scissors to cut a sheet of adhesive paper in half, then remove the paper backing from one of the adhesive halves.

3. Place the sticky side of the adhesive on the shiny side of the tattoo paper and press firmly to remove bubbles. ▸

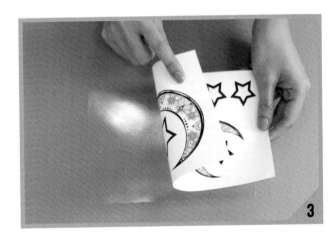

4. Remove the clear film to expose the other side of the sticky adhesive and press the adhesive paper onto a piece of gold leafing.

5. Remove the paper backing from the second half of the adhesive paper and press the sticky side on top of the gold leaf sheet.

6. Turn the tattoo paper over so you can see the mirror images of the stars and moon on the underside of the tattoo paper. Then use scissors and a craft knife to carefully cut out the shapes.

7. Take the moon tattoo, remove the clear film on the adhesive, and place it on the nape of the neck close to the left shoulder. Next place a star in the crescent of the moon and then place the rest of the stars on the nape of the neck.

8. Soak a makeup wedge in water and shake off excess. Gently dab the backing of the tattoo until

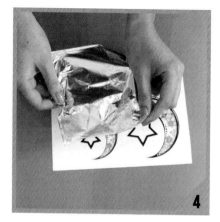

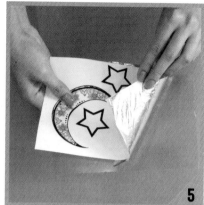

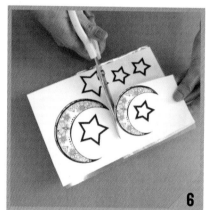

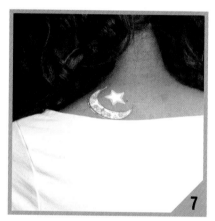

the paper is saturated. Carefully peel away the backing from the tattoos to expose the design.

9. Wipe off any excess water and begin to wish upon the stars!

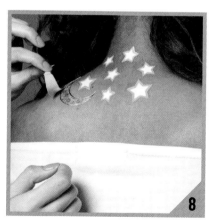

Sparkling Aurora

What's more surreal and magical than the chance to see the aurora borealis—the northern lights—in action? There's a reason this famous light show has been on many people's bucket lists for decades. To catch a glimpse of nature showing off its magnificence would be a dream for most, but if you're stuck at home, don't worry! This Sparkling Aurora tattoo will sketch that dream right onto your skin!

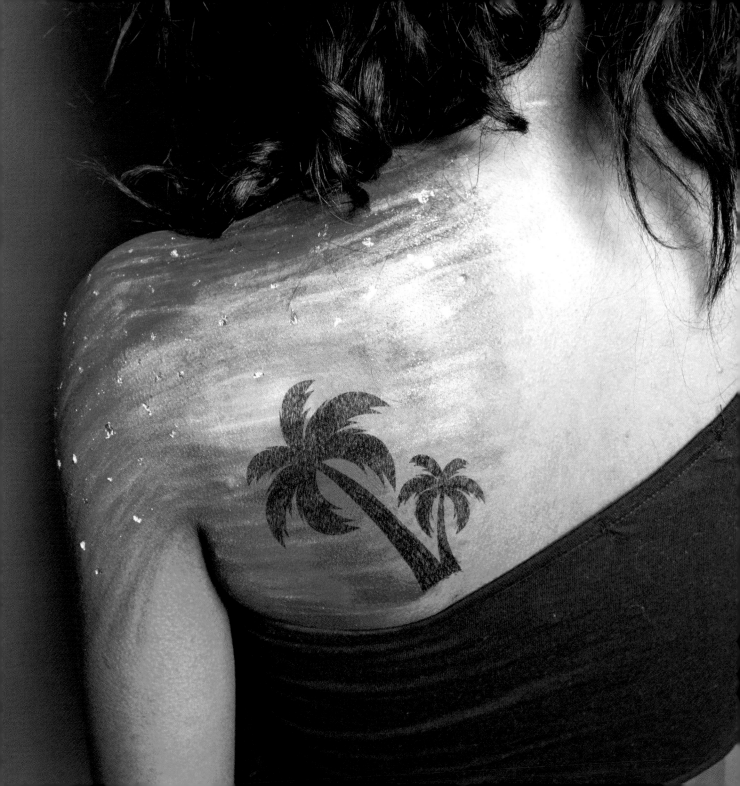

MATERIALS

* Face and body paint crayons (*I used purple, pink, blue, yellow, white, orange, and red*)
* Tweezers
* 1 (3.15" × 3.15") sheet gold leaf
* 1 large blush brush
* 1 (1-ounce) container pearl pigment mica powder
* 1 black liquid eyeliner pen

* * *

1. Take the white crayon and use it to cover about 7" × 9" of the left shoulder, or wherever you choose to apply the design. The white should be close to opaque. It's okay if you see little streaks of your skin, but the better covered the better the results!

2. Use the dark purple crayon to color over the top couple of inches of the white base. Be sure to apply enough pressure so that it completely covers up any white that is peaking through.

3. Take the blue crayon and add about 1–2" of blue crayon where the purple crayon ended, then smudge the blue and purple together. Continue to color in more of the white with the blue crayon, but leave a 2–3" space in the center of the white base uncolored. ▸

4. Next, take the pink crayon and add pink where the blue crayon ended, then smudge the pink and blue together. Then color in the rest of the white base with pink, again being sure to leave the spot of white in the middle.

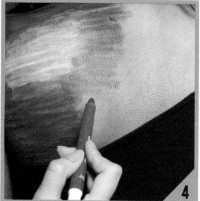

5. Use orange and yellow crayons to color over the top of all the other colors and to fill in the white space in the center. It's best to color in with the orange first and then blend in the yellow to create a well-lit landscape.

6. While the pastels are still wet and sticky, take the tweezers and tear off 40–50 pieces of gold leafing from the sheet. Use the tweezers to press the gold pieces into the pastels about 2" apart.

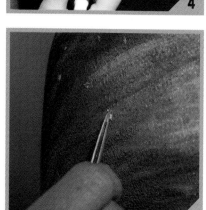

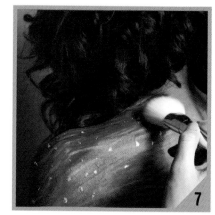

7. Next, dip the brush into the glitter dust and dust it over the dark purple part of the design.

8. Finally, after the crayons have completely dried onto the skin, about 5 minutes, take the eyeliner pen and draw in silhouettes of 2 palm trees along the bottom of the design. The larger palm tree

should be about 5" × 3" and the smaller one, which should hang onto the right of the larger tree, should measure about 3" × 2".

9. Allow the eyeliner to dry about 5 minutes or until completely dry to the touch, then head out and add even more sparkle to your night.

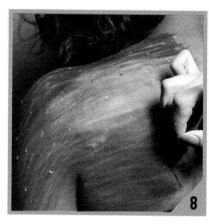

Intergalactic

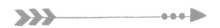

Our universe is so vast that it sometimes feels
that Earth is nothing more than an unsubstantial
speck in the galaxy. Fortunately, you can ground
yourself while wearing this ephemeral, glow-in-
the-dark Intergalactic tattoo. It's amazing to
be able to re-create the universe on your body,
and then see it come to life with the flip
of a light switch!

MATERIALS

- ★ 1 large blush brush
- ★ 4 (10-gram) containers colored UV-activated powder *(I used white, pink, yellow, and blue)*
- ★ 2–3 makeup wedges
- ★ 1 (⅛") round liner brush
- ★ 1 (0.5-ounce) tube white UV-activated paint
- ★ UV light or bulb *(not pictured)*

★ ★ ★

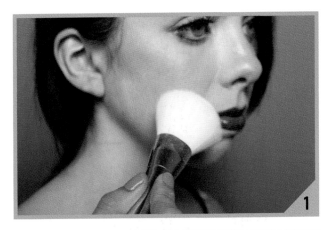

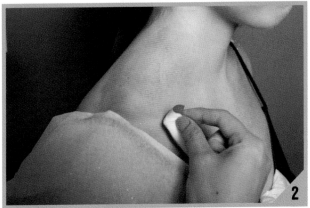

1. Dip the blush brush into the white UV-activated powder and apply it to the right shoulder, along the neckline, stopping about 1" above the jawline.

2. Dip a makeup wedge into the pink powder and dab it along the neckline, shoulder, jawbone, and collarbone.

3. Dip a clean makeup wedge into the yellow powder and dab it along the collarbone and under the jawbone. If you happen to accidentally mix the yellow and pink powder together, that's completely okay. Just keep tapping with your makeup wedge. The two colors blended together will create orange.

4. Take another clean makeup wedge, dip it into the blue powder, and gently dab right under the collarbone and slightly closer to your right sternum.

5. Finally, dip the liner brush into the white UV-activated paint and add pin-sized dots and ⅛–¼" asterisks to the jawline. Then continue to add them, following the neckline down to the right shoulder.

6. Let the UV-activated paint dry about 5 minutes or until dry to the touch. Then turn off the light, turn on the UV lamp, and watch yourself be out-of-this-world spectacular!

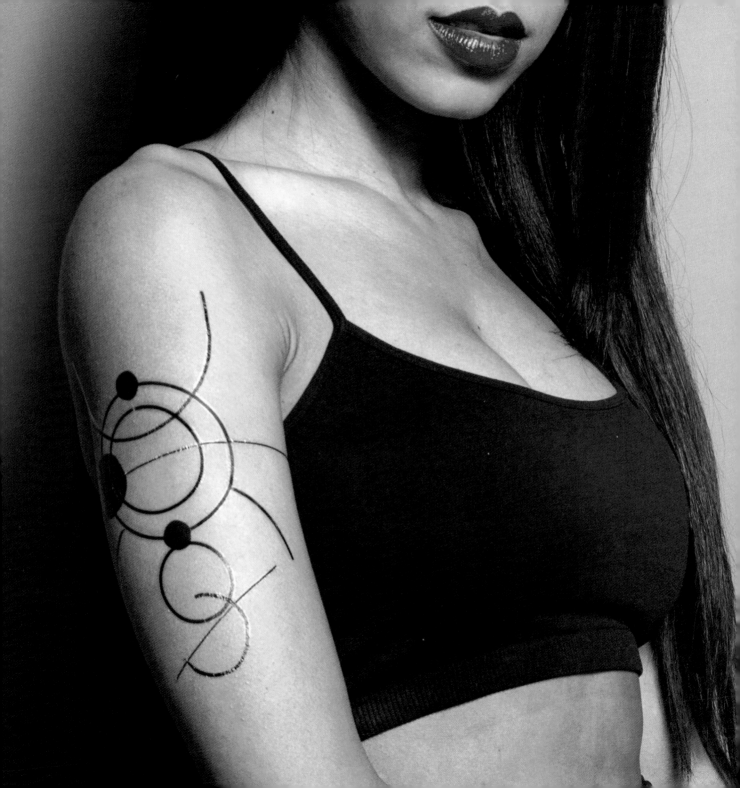

Our Universe

I'm sure you've heard of the saying "The universe doesn't revolve around you." Well, with this awesome solar system tattoo it doesn't have to. This temporary art will draw so much attention that people will think you have your own unique gravitational pull. So take your lighthearted spirit and get ready to play astronaut by creating a universe of your very own, without ever taking your feet off the ground!

MATERIALS

→

* Our Universe template (Appendix A)
* 1 (8.5" × 11") temporary tattoo paper sheet with a clear adhesive sheet (not pictured)
* Scissors
* Craft knife
* 2–3 makeup wedges

* * *

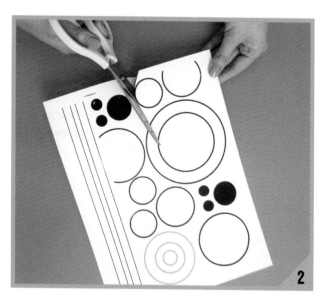

1. Scan the Our Universe template into your printer and print on the shiny side of the tattoo paper. Next, remove the paper backing from the adhesive. Then place the sticky side of the adhesive onto the shiny side of the tattoo paper and press firmly to remove bubbles.

2. Use scissors and the craft knife to carefully cut out the circles and lines. Take care to cut as closely as you can to the lines and not on the actual lines. If you are cutting out a full circle, use a craft knife to do so, to avoid separating the circles or lines.

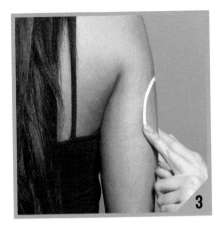
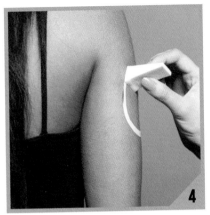
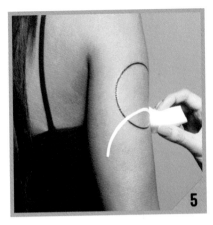

3. Take the largest circle and remove the clear film from the adhesive sheet on the tattoo. Then place it sticky side down on the outer part of your upper arm and press firmly to make sure it adheres.

4. Soak a makeup wedge in water and shake off excess. Gently dab the backing of the tattoo with the wedge until the paper is saturated. Carefully peel away the backing from the tattoo to expose the design.

5. Take one of the curves that you cut out and apply it with the arc facing downward overlapping the previous circle by 1". Repeat step 4.

6. Take the medium circle and place inside the larger circle. Repeat step 4.

7. Place one small solid dot at the top of the larger circle and one at the bottom. Repeat step 4.

8. Place the larger solid dot to the left on top of the larger circle. Repeat step 4.

9. Take another curve, with the curve facing upward, and place it so it overlaps the first larger circle you started with earlier. Repeat step 4.

10. Take the line and use your scissors to cut it in half, then place it in the center of the first circle going across. Repeat step 4.

11. Apply the smallest hollow circle at the bottom, overlapping the solid dark circle. Repeat step 4.

12. Take the other half of the line and angle it going from the bottom left to the upper right at the edge of the previous circle. Repeat step 4.

13. Lastly, finish the tattoo with a small arc overlapping the angled line. Repeat step 4.

14. Before heading out of the house, simply wipe off any excess water and go ahead and show off your new universe!

Beautify Me

Getting a makeover these days can be super simple or really involved. But no matter the technique you choose in this chapter you'll find everything you need to amplify your look, from golden freckles that make your face shine to red lips that last overnight to gorgeous nail tattoos that bring the feeling of Coachella to your everyday life. So grab your gold foil, your nail polish, and your henna and get ready to amp up your natural beauty!

Gold Headbands

Historically the olive tree has been a symbol of peace. This Gold Headbands tattoo lets you show your peaceful intentions wherever you go. Wear it to that multiday music festival. Show it off to your friends. It'll tell everyone you see what you stand for—and you won't even have to say a word.

MATERIALS

→

* Gold Headbands template (Appendix A)
* 1 (8.5" × 11") temporary tattoo paper kit with a clear adhesive sheet (not pictured)
* Scissors
* 1 nontoxic all-purpose glue stick
* 1 (3.15" × 3.15") sheet gold leaf
* Craft knife
* Hairbrush or comb (not pictured)
* 1 (2.2-ounce) bottle extra-hold hairspray (not pictured)
* 1–2 makeup wedges

* * *

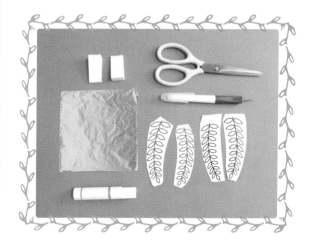

1. Print both images from the Gold Headbands template on the shiny side of the tattoo paper. Then print the mirror images on the other side of the tattoo paper. Use the scissors to cut out each image.

2. Use the glue stick to apply a thin layer of glue over the images on the shiny side of the tattoo paper. Be careful not to smear the ink by pressing the glue stick too hard.

3. Take the tattoo image with the glue side face-down and apply it onto a sheet of gold leaf, letting the glue adhere to the gold leaf. Be sure to flip it over and gently tap on the gold leafing to remove any air bubbles trapped under the leaf.

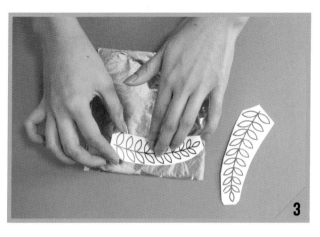

4. Peel off the paper backing from the adhesive paper and press the sticky side of the adhesive firmly onto the gold leaf.

5. Turn the tattoo paper over so you can see the mirror images on the underside of the tattoo paper. Then use scissors and a craft knife to carefully cut out the branches.

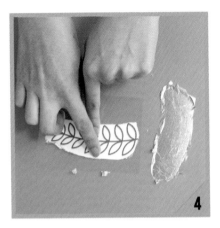
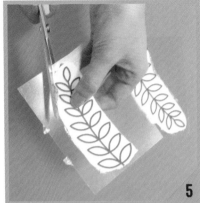

6. Brush or comb the hair and part it in the middle. For best adherence use 2–3 sprays of hairspray so the hair stays slick and smooth.

7. Remove the clear film on one of the olive branches and place it horizontally about 3" away from the part in the hair. Repeat this step on the opposite side of the part with the remaining olive branch.

8. Soak a makeup wedge in water and shake off excess. Gently dab the backing of the tattoo with the wedge until the paper is saturated, taking care to only wet

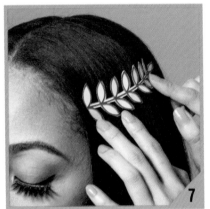
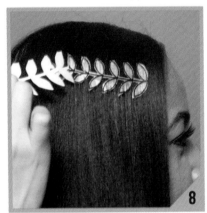

the white backing of the paper and not the already hairsprayed hair. Carefully peel away the backing from the tattoo.

9. Wipe up any excess water, head out the door, and spread your message of peace wherever you go. ▸

TATTOO TIPS

Since hairspray will be used for this project, it's best to do this look on days that you aren't planning to wash your hair. The longer you go without washing your hair, the easier it is to achieve this look since your natural oils will help keep your hair nice and slick without too much hairspray. For you lovely ladies with curly or wavy hair, it's best to straighten out your hair or the section where you would like to apply the tattoo. This will give the tattoo a smooth canvas to adhere to.

Floral Hair

Don't you wish that beautiful hair was as simple as picking an image that you like and just spraying it onto your hair to wear as an accessory? Well, with this Floral Hair tattoo, edgy hair days are now an everyday guarantee. This project gives you everything you need to add a seductive red rose to your hairdo—a perfect look for a night out. But if you want to personalize your look, just choose an image with bold lines and simple details that works for the occasion and you'll turn heads wherever you go.

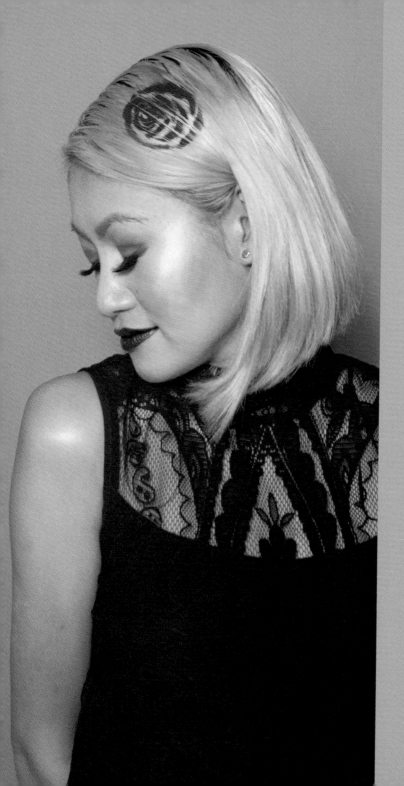

MATERIALS

* 1 (8.5" × 11") sheet sticker paper *(not pictured)*
* Floral Hair template (Appendix A)
* Scissors
* Craft knife
* Hairbrush or comb *(not pictured)*
* Extra-firm hold hairspray
* 1 (3-ounce) bottle magenta temporary hairspray

* * *

1. Scan the Floral Hair template into your printer and print on the sticker paper.

2. Use the scissors to cut around the image, then use the craft knife to cut out the details of the flower, leaving the negative space intact to create a stencil.

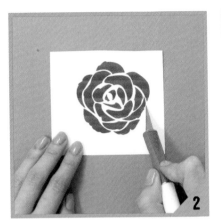

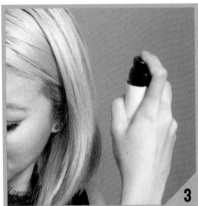

3. Prepare the hair by brushing or combing it flat onto one side, then spraying it with a touch of hairspray for 1–2 seconds. The hold should be firm and the hair should act as one large piece. Let the hairspray dry to the touch, about 2–3 minutes.

4. Peel the backing off of the sticker sheet and apply it to the prepared part of the hair.

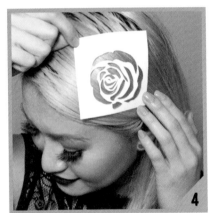

5. Hold the can of colored hairspray about 2" away from the hair and carefully spray the hair inside the stencil. To avoid spray outside of the sticker paper, cover up any extra hair with a piece of paper. Let the spray dry completely, about 2–3 minutes.

6. Gently peel away the stencil and enjoy a flower that never wilts!

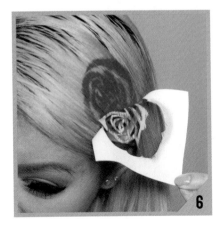

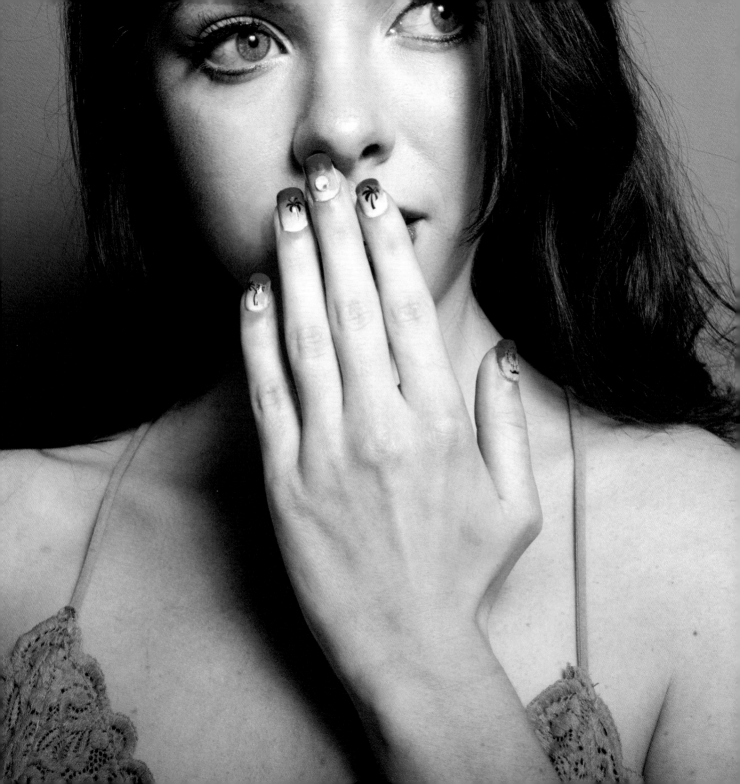

Sunset Coachella

The perfect relaxing day for most people would probably be sitting outside with drink in hand watching the sunset. Then, once the sun goes down, you'd head out to experience the ultimate show at Coachella. If you can't actually get away, take a deep breath and let this Sunset Coachella nail tattoo take you back to one of the best weekends of your life.

MATERIALS

* 4 (0.5-ounce) bottles lacquer nail polish
 (I used white, red, orange, and yellow)

* 2–3 makeup wedges

* ⅜" round brush

* Nail polish remover (not pictured)

* Sunset Coachella template (Appendix A)

* 1 (8.5" × 11") sheet temporary tattoo paper
 (not pictured)

* Scissors (not pictured)

* 1 (0.1-ounce) bottle nail glue (not pictured)

* Tweezers (not pictured)

* 2 (5 mm) clear rhinestones

* 1 (0.5-ounce) bottle clear glossy quick-dry
 top coat nail polish

* * *

1. Use the white nail polish to paint each fingernail. Repeat as needed. Then let the paint dry completely, about 30–40 minutes.

2. Take the red nail polish and paint a line of polish on the top of the slanted side of a makeup wedge.

3. Directly below the line of red polish, add a line of orange nail polish. Then add a line of yellow nail polish directly below that.

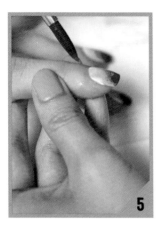 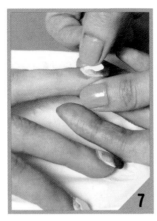 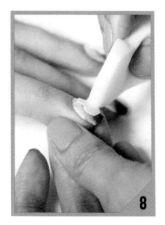 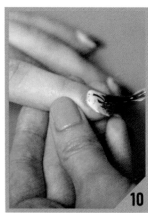

4. Take the wedge and gently polish one nail with the wedge using a rocking motion from left to right. Repeat this on all other nails. When you notice that the color isn't transferring onto the white polish, reapply the paint colors to the makeup wedge. Repeat these steps on both hands.

5. Before the polish is completely dry, dip the round brush in the nail polish remover and use it to clean up any excess polish on the skin. Then let the nail polish dry to the touch, about 20–30 minutes.

6. Scan the Sunset Coachella template into your printer and print on the shiny side of the tattoo paper. Then use the scissors to carefully cut out the shapes.

7. Remove the clear film on the tattoo paper and apply the images face-down on each nail except the middle fingers.

8. Soak another makeup wedge in water and shake off excess. Gently dab the backing of the tattoos with the wedge until the paper is saturated. Carefully peel away the backing from the tattoos and wipe away any excess water before moving onto next step.

9. Apply a pin-sized dot of nail glue to the middle of the nail on the middle finger. Then use tweezers to pick up a rhinestone and press it firmly onto the nail glue. Repeat with the remaining rhinestone on the other middle finger. Let the glue dry completely before proceeding, about 1 minute.

10. Paint each nail with the clear nail polish to seal the look. Allow the top coat to dry to the touch, about 15 minutes, then head out to enjoy your sunset.

Golden Freckles

Freckles say a lot of different things to different people. To some, freckles are cute. To some, they're cheeky. And to others, they're totally cheeky! If you've been jealous of those ladies who rock this amazing look, don't worry! These Golden Freckles will take your look up a notch and gild you with some cheeky confidence!

MATERIALS

→

* ★ Tweezers
* ★ 1 (3.15" × 3.15") sheet gold leaf *(Note: You will not need a full sheet for this project.)*
* ★ 1 (0.3-ounce) tube brush-on eyelash glue

★ ★ ★

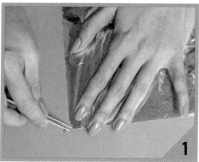

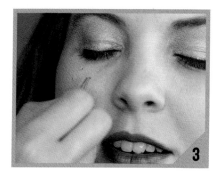

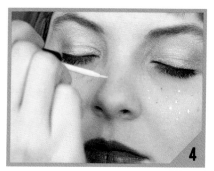

1. Use the tweezers to carefully and gently tear off 30–40 tiny pin-sized pieces of gold leaf from the sheet.

2. Take the eyelash glue and gently apply a pin-sized dot of glue wherever you'd like the first gold freckle to be placed. Try the apple of the cheek or the bridge of the nose.

3. Use the tweezers to carefully pick up and place the gold freckles on the glue. Then use your fingers to gently tap the freckle to flatten out any wrinkles or bubbles.

4. Repeat steps 2–3 until you have a nice smattering of golden freckles on the apples of the cheeks and across the bridge of the nose. Then walk out the door and turn some heads!

Henna Nail Art

In this project your nails are total rock stars. Here, you're able to let your imagination—and your artistic streak—run amok to create nail tattoos that everyone will notice and everyone will want.

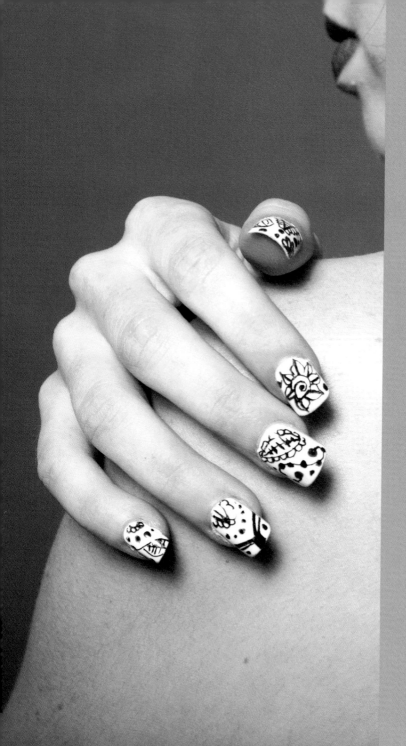

* 1 (0.5-ounce) bottle white lacquer nail polish

* 1 black nail art pen

* 1 (0.5-ounce) bottle quick-dry extra-shiny top coat nail polish

* * *

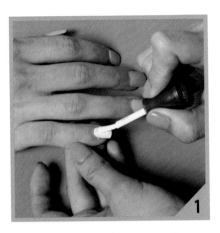

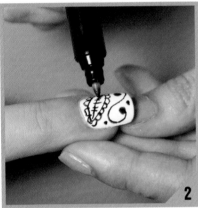

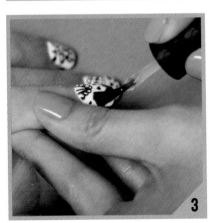

1. Use white nail polish to paint each fingernail. Repeat with a second coat as needed. Allow polish to dry to the touch, about 20 minutes.

2. Use the nail art pen to draw leaves diagonally on the nails. Then decorate the leaves with some scallops going around the edges of the leaf. If there is too much negative space, you can fill it up with a simple S squiggle and dots in varying sizes.

3. Paint each nail with the top coat to seal the look. Allow the top coat to dry to the touch, about 15 minutes, then let your hands speak for themselves!

TATTOO TIPS

Keep designs simple by using easy dots and swirls. And, if you want to mix it up with another design, just create a spiral at the very middle of your nail, and then draw petals that radiate out from the spiral. Again, you can fill up any blank spaces with S squiggles or dots. Remember that you don't have a lot of space on your nails so don't try to be too detailed or the design will look smudgy and the details will run together.

Tattoo Stains

Let's be honest, sometimes it seems that you spend more time applying your makeup than you actually do wearing it and enjoying your look. It stinks to go through all that effort and still be barefaced at the end of the night! Fortunately, this project gives you amazing lips and brows that you can rock for days on end—and you won't even wake up with a smudged face.

MATERIALS

* 1½ tablespoons clear nontoxic glue
* 2 (3" × 3") glass containers
* 2 teaspoons red drink mix (I used Kool-Aid)
* 2 small spoons (not pictured)
* 2 (¼") round brushes
* ½ teaspoon orange drink mix (I used Kool-Aid)
* ½ teaspoon blue drink mix (I used Kool-Aid)
* ¼ teaspoon purple drink mix (I used Kool-Aid) (not pictured)
* Tweezers (not pictured)

* * *

1. Squeeze 1 tablespoon glue into each of the glass containers.

2. For Lip Stain: Add red drink mix to one of the containers with the glue.

3. Use a spoon to thoroughly mix the glue and powder until the powder is completely dissolved.

4. Dip one of the round application brushes into the glue mixture and apply it to lips.

5. Allow the glue to dry 5–10 minutes or until dry to the touch.

6. For Eyebrow Stain: Add blue, orange, and purple drink mixes to the unused container of glue.

7. Use a spoon to thoroughly mix the glue and powder until the powder is completely dissolved into the glue.

8. Dip the remaining clean round application brush into the glue mixture and apply it to eyebrows. (Note: It's best to practice with the powder before you try this out.)

9. Allow the glue to dry 5–10 minutes, until dry to the touch.

10. To finish: Once the eyebrow and lip stains are dry, use tweezers to gently peel off the glue and reveal a beautiful hue of colors that will last through any festival! ▸

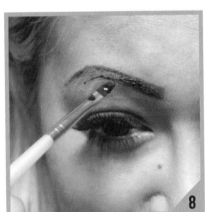

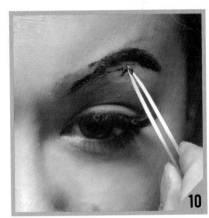

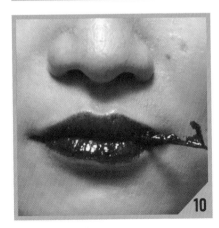

TATTOO TIPS

Depending on the color of your eyebrows, you may want your eyebrow stain to be lighter or darker than what you see in the photos. If you are aiming for a taupe color, use a mixture of blue, orange, purple, and reds. If you are trying for more of a grayish tone, try blue, purple, green, and just a little bit of orange. If you want a light brown, try orange as the main color and then slowly add purple to make it more brown. You will have to play around with ratios to get the tint that will match your eyebrows. Best to start lighter and then build up.

Painted Cuticles

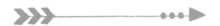

Have you ever painted your nails and ended up painting your cuticles as well? Well, this tattoo lets your cuticles do all of the talking! This Painted Cuticles tattoo is also a great way to wear a henna-like design without the commitment that henna brings to the table. If you're afraid of using the durable ink to create a big tattoo such as the Large Henna Chest Piece in Chapter 4 or the White Henna Zebra in Chapter 5, but still want to experiment, you're in luck. With this project, just a hint of henna gets the point across.

* 1 (0.5-ounce) bottle white lacquer nail polish
* 1 black liquid eyeliner pen (*Note: Be sure to use waterproof, long-wear liquid eyeliner.*)

* * *

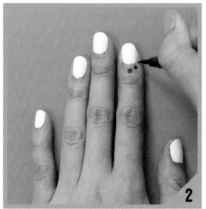

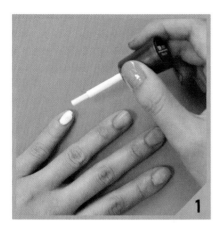

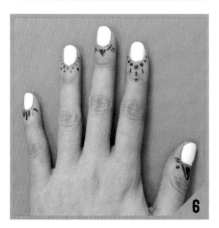

1. Use the nail polish to paint each fingernail. Repeat as needed. Then let the paint completely dry, about 20 minutes.

2. Use the eyeliner pen to add a series of dots to the cuticle of the index finger following the curve of the nail. Then draw three lines straight down, directly under the row of dots and add a small dot underneath the line in the center.

3. On the cuticle of the middle finger draw a triangle about ¼" wide and fill it in. Draw a line heading up to the fingertips on each side of the triangle and then add two small lines under the angled lines.

4. On the ring finger, add about 10–15 dots along the cuticle. If your fingers are too small to add the dots in a row, feel free to add them in two rows.

5. Draw 7–8 lines on the pinky radiating from the end of the cuticle.

6. On the thumb add a triangle about ⁵⁄₁₆" wide and fill it in. Draw a large V under the triangle, then add 2 lines on each side of the triangle and V. Place a dot in the empty space between the V and the bottom lines on each side.

7. Once you've finished decorating your cuticles, allow the eyeliner to dry to the touch, about 1 minute, and then show off your tattoos to your friends.

Tattoo Templates

If you're worried about not being able to draw or even find the art that you need for the tattoo projects throughout the book, don't be! Here you'll find a template for every image-specific tattoo in the book. If you want to use other images, absolutely feel free to find them online and incorporate them into the tattoo ideas that I've given you, but if you want to re-create the tattoos exactly as seen throughout the book I've got your back!

METALLIC LOTUS FLOWERS

Lotus Image 1

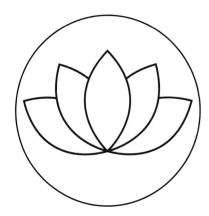

Lotus Image 2

WALLFLOWERS

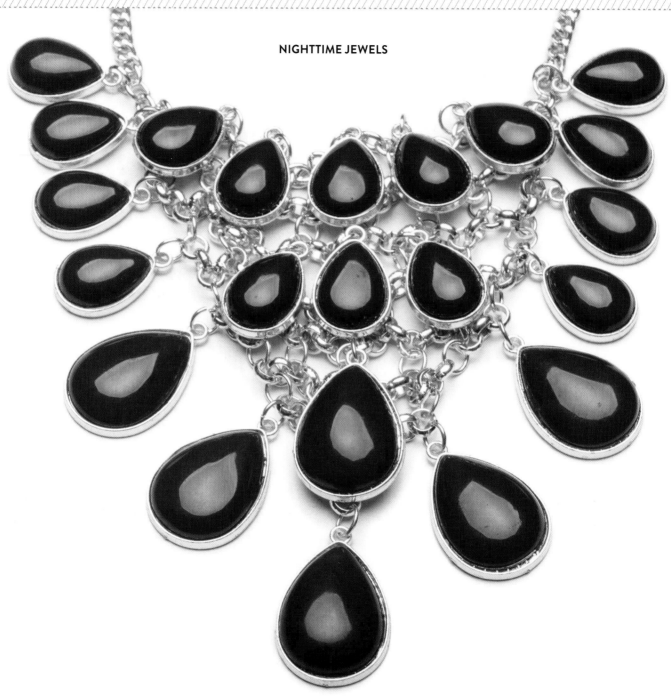

MASQUERADE

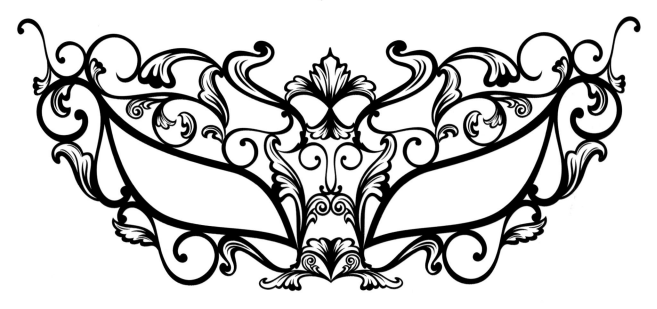

VISIBLE GARTER

METALLIC UNICORN HORN

LOW-POLY TISSUE PAPER FOX

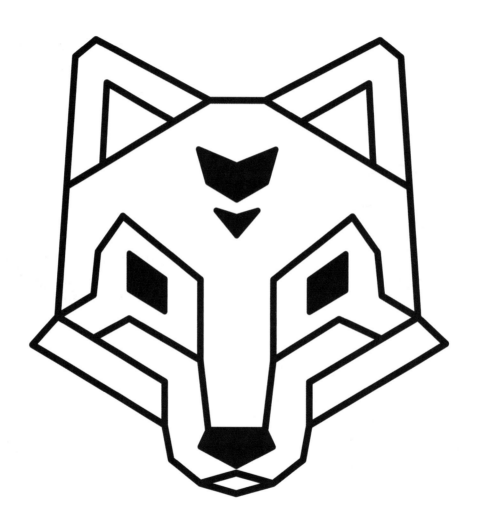

DELICATE FEATHERS

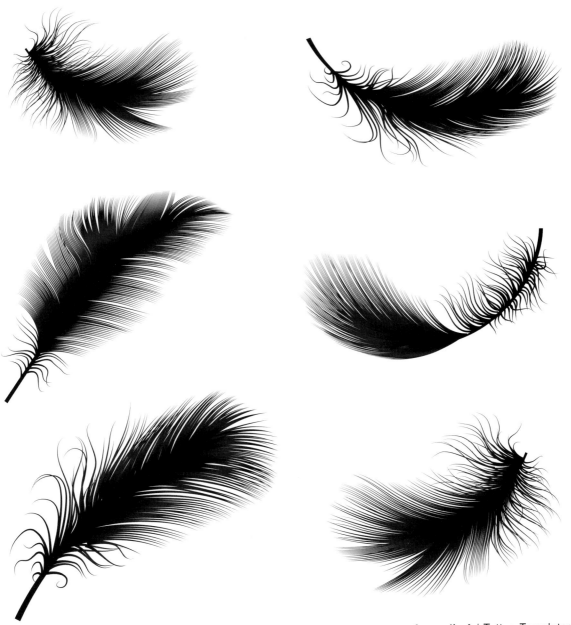

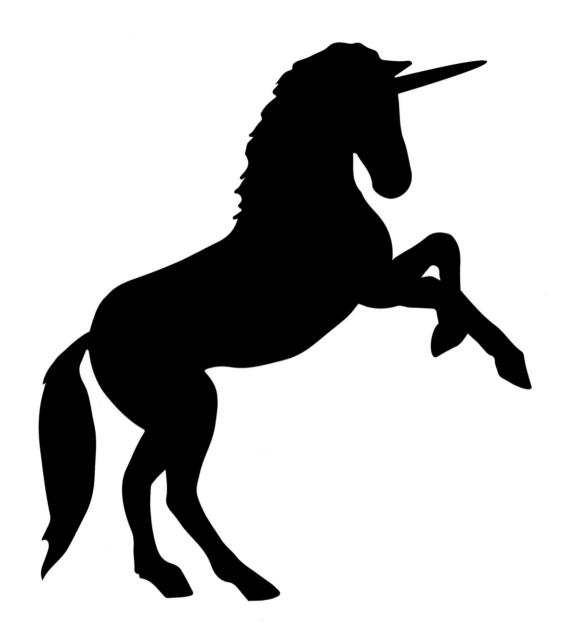

GLOWING CONSTELLATIONS

Virgo

Capricorn

Pisces

Taurus

Aquarius

Scorpio

Libra

Gemini

Sagittarius

Leo

Cancer

Aries

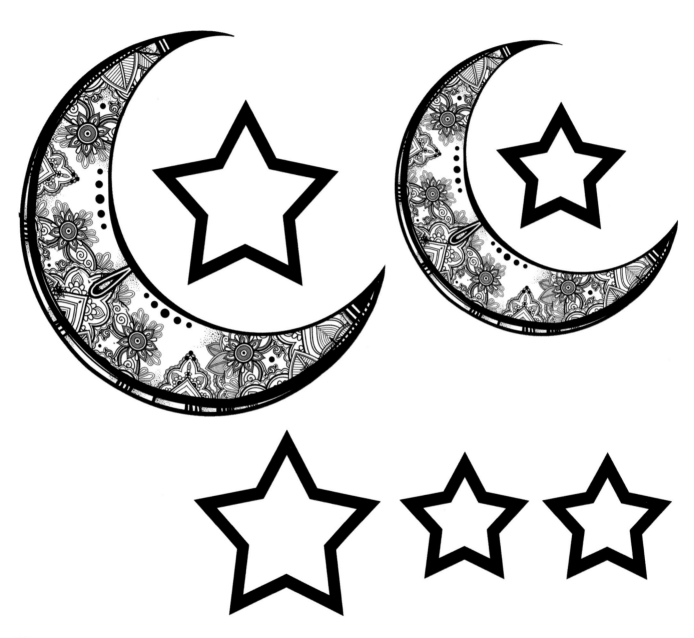

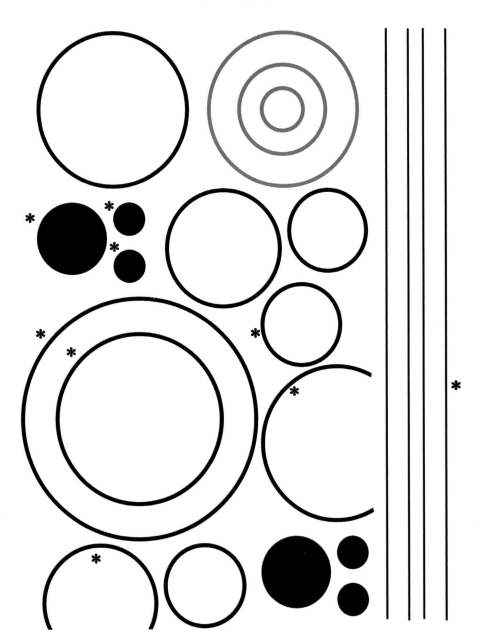

FLORAL HAIR

SUNSET COACHELLA

U.S./Metric Conversion Charts

VOLUME CONVERSIONS

U.S. Volume Measure	Metric Equivalent
⅛ teaspoon	0.5 milliliter
¼ teaspoon	1 milliliter
½ teaspoon	2 milliliters
1 teaspoon	5 milliliters
½ tablespoon	7 milliliters
1 tablespoon (3 teaspoons)	15 milliliters
2 tablespoons (1 fluid ounce)	30 milliliters
¼ cup (4 tablespoons)	60 milliliters
⅓ cup	90 milliliters
½ cup (4 fluid ounces)	125 milliliters
⅔ cup	160 milliliters
¾ cup (6 fluid ounces)	180 milliliters
1 cup (16 tablespoons)	250 milliliters
1 pint (2 cups)	500 milliliters
1 quart (4 cups)	1 liter (about)

WEIGHT CONVERSIONS

U.S. Weight Measure	Metric Equivalent
½ ounce	15 grams
1 ounce	30 grams
2 ounces	60 grams
3 ounces	85 grams
¼ pound (4 ounces)	115 grams
½ pound (8 ounces)	225 grams
¾ pound (12 ounces)	340 grams
1 pound (16 ounces)	454 grams

LENGTH CONVERSIONS

U.S. Length Measure	Metric Equivalent
¼ inch	0.6 centimeters
½ inch	1.2 centimeters
¾ inch	1.9 centimeters
1 inch	2.5 centimeters
1½ inches	3.8 centimeters
1 foot	0.3 meters
1 yard	0.9 meters